POSTCARD HISTORY SERIES

Mystic

To Helen

Joelle

M. Earl Smith

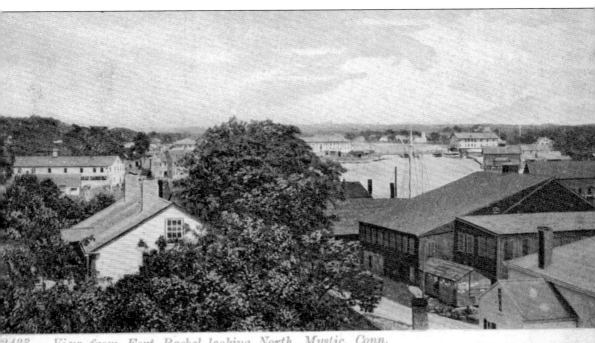

2433 — *View from Fort Rachel looking North, Mystic, Conn.*

I had an awful time geting here

This 1908 postcard features Fort Rachel (now a marina), which was built by Mystic farmers and mechanics in just one month during the War of 1812 and maintained by a Scottish immigrant. It was named for the beloved "Aunt Rachel" who lived just a few steps away and translated sailors' dreams, gave cold drinks from her spring, and dispensed patriotic wisdom (jokingly at first). It boasted a "four pounder [cannon] that could sink barges as far off as Mason's Island, Sixpenny Island," according to source texts. The sender wrote, "I had an awful time getting here"—unsurprising for a January arrival. (Authors' collections.)

FRONT COVER: Published by Danzinger and Berman, this 1907 card shows an artist's rendition of the famed Gilbert Block in Mystic. Before the rise of the automobile, this card shows a life where horse and carriage was the primary mode of transportation. Notable is the trolley rail, which had been installed in 1904, even amongst the dirt roads of the area. Businesses, such as E.B. Noyes Carpet, can be seen along the side of the street. (Authors' collections.)

BACK COVER: Postmarked three different times in 1906, this card shows the Mystic Bridge. On the front is written "Hello Kane! Guess who I am." The card is addressed to Miss Alice F. Kane, 32 Vicksburg Street, Providence, Rhode Island. First postmarked in Mystic on February 26 at 5:30 p.m., the card was later received at North Station before finally arriving in Providence on February 27 at 5:30 a.m. (Courtesy of Debbie Hindman.)

POSTCARD HISTORY SERIES

Mystic

J. Huguenin and M. Earl Smith

ARCADIA
PUBLISHING

Published by Arcadia Publishing
Charleston, South Carolina

Printed in the United States of America

Library of Congress Control Number: 2016958072

For all general information contact Arcadia Publishing at:
Telephone 843-853-2070
Fax 843-853-0044
E-mail sales@arcadiapublishing.com
For customer service and orders:
Toll-Free 1-888-313-2665

Visit us on the Internet at www.arcadiapublishing.com

To the young generations who, as we speak, are shaping the future history of Mystic: Never forget to tell your own stories.

Contents

ACKNOWLEDGMENTS

Mark Twain told Mystic legend Chas Q. Eldredge, "Before you write a book, be satisfied in your own mind that it will make the reader laugh or cry." Considering that I, J. Huguenin, grew up in Mystic, I've spent years there doing both. From First Nights and pizza dates with Christine, Elsa, Jenny, Becky, and Kate; to my first date at a German Club concert; to hounding "Chip" Hawkins as he waited tables; to accidental wedding crashing at the Seamen's Inn; to drinks at the Green Marble Café with Rob; to Daniel Packer Inne dancing to James Harris's acoustic renditions of *Hotel California*; to Drawbridge Ice Cream at the Mystic River Park with Nova; to Cocktails With Whales with Cody, Dustin, and Alyssa; to meeting the first American women submariners at Margarita's; to introducing my coauthor to the coast, and all the way through this publication, I have forged my share of history with Mystic, and now M. has some Mystic history of his own.

These memories, of course, do not happen in a vacuum. The first time I, M. Earl Smith visited Mystic, I was eager to celebrate my just-completed first Arcadia title. J. was more than happy to show me around, and I quickly fell in love with New England's charm and seafaring heritage. It was then that the idea for the Postcard History series book *Mystic* was born. I have to thank, before all else, my lovely and talented partner for the inspiration and motivation to complete this volume. Much love and thanks go to my children (Nick, Leah, and Lydia) and my family, for their encouragement and material. Special thanks go to Melissa Jensen, my creative writing sensei, for all the writing tips—and the motherly advice in patience and understanding.

We must also thank Beth Sullivan, Bryan Bentz, Michael Spellmon, fellow Arcadia author Jim Streeter, local oracle Ellery Twining, and University of Vermont professors Paul Bierman and Thomas D. Visser. Thank-yous go to J's family (for their food and parlor) and, finally, to the fluff-bucket sheltie Nova. Unless otherwise noted, all images appear courtesy of the authors.

INTRODUCTION

My first job, as many Mystic residents before and since, was as a dishwasher in one of the local restaurants. Due to extraneous circumstances, I found myself as a high school junior on the line as the second chef two nights a week, five months after my first day on the job. Surprisingly, I was quite competent at supporting the head chef, and became proficient enough that some of the staff would ask me to prepare them a meal following the dinner shift. One night, while cooking a simple tenderloin dish for one of the waiters, I accentuated every mistake a cook can make with scorching oil: I absentmindedly tossed the tenderloin into the pan, and a small wave of boiling oil shot out from the pan and landed directly on the top of my right hand—the hand that kept the beat in my burgeoning local rock band. As the blistering skin began to rise, I took two stab steps toward the sink and grabbed the "cold" faucet with all of the speed I could muster from my left hand.

As I acclimated an inner understanding of the need for my hands to be unblemished by employment, I applied for a position at the Emporium, a retail institution in downtown Mystic. I had become an acolyte of the Emporium aesthetic at an early age—the eldest son of my father's childhood best friend was an employee during an initial height of the stores popularity in the early 1980s. The building that housed the Emporium was built in 1859, and served as a post office during the Civil War, and its stately resonance remained through the years. When I arrived for my first day on the job, the store was in the throes of the Pop Revolution of the 1980s—rainbow decals, shades tinted in primary colors, rice paper shades, iconic poster prints, as well as the effervescent scent of fine soaps and "crying necessities." The store was a monument to a moment in time, and many of those cultural aspects were instilled within the lives of those of us who worked the "Three Floors of Fun."

The intransigent, singular effect of the Emporium on me as an artist was the postcard collection. Greeting cards revealing intimate details of any celebration were commonplace, as were the traditional cards for every moment you did not want to completely acquiesce to. The full spectrum of pre-Internet communication was available to the customers at the Emporium, especially within the postcard section: the beauty of Avedon, the rapturous delight of Ultra Violet under an American flag; Degas, Matisse, McKenna, Monet, Stein, Klee, Basquiat—their work rendered in postcards—the totality of image—a Warholian revolution reaching to the tiny village of Mystic; 15 minutes as an eternity of inspiration.

I was in Amsterdam for the first time in 1997; the locals spoke better English than we did. One of the largest producers of the postcards we sold at the Emporium was in Utrecht, Netherlands. The Amsterdam postcard shop that we visited was stocked with every image we had at the Emporium, the bulk of which held the Utrecht logo, and that is when the totality of a specific reality struck me—the Emporium was on the leading edge. I perused the bins for a complete hour, finding seven new additions to my collection—which I had attributed to a love of Polaroid film, a fascinating success of technology during my youth. When original Emporium founders Lee Howard and Paul White left New York City, following successful

careers as a Broadway actor and painter respectively, they undertook a renovation of the building, which was complete by 1965. This introduced the Emporium to the village. Their commitment mirrored that of another New York City artist's migration to Mystic. They were in step with their time, which would shape and define our time.

Charles Harold Davis, an active tonalist painter, who had studied extensively in both Paris and New York City, relocated to the riverside village in 1890. The Mystic Art Association, a block away from the Emporium building, was born of his desire to make a mark of permanence in the village that he had come to appreciate as home. His vision was validated on August 11, 1951, as Garrett Price of the *New Yorker* illustrated the cover for that issue of the magazine with several city artists hanging the annual show in the MAA gallery. Those artists found their alternative home within the confines of the valley.

Mystic has always been at the leading edge. The definition of the village is the singular reason why these postcards have meaning at all: a communication—the widow's walk above the rooflines of West Mystic Avenue—captains' wives waiting patiently and desperately hoping for some news of their loved ones, whether it be a post, or the view of the ship's mast at the entrance to the river (Were rumors of an accident in the shipyard true? Reports of a capsized boat? News of an imminent tidal surge?)—the shipbuilder dealing with accidents at the site, coupled with the insurance concerns of the ship's owners. There are few postcards of their daily lives, the citizens of Mystic who created the high tide of the shipbuilding era. There are many postcards of the Victorian age to the present, with the drawbridge as the central star. We have a historical record, but not their definition. To paraphrase local historian Carol Kimball, interviewed in Bailey Prior's excellent documentary *Mystic: An American Journey* from 2004: "The divide that the river represents is actually the very thing that unites us."

I was struck by Carol's words. My conception of what Mystic represented began in the potent gallery of the Emporium's postcard collection. Her call was for a more nuanced realization from Mystic citizens of where we stand in the scope of the history of the village.

This collection hopes to make that picture more complete.

—Ellery Twining,
Mystic Postcard Publisher

One

ANCHORS AWEIGH!
SHIPS, SCHOONERS, AND SAILBOATS

Divided between the townships of Groton on the west side and Stonington on the east, Mystic was destined from its inception to be a port, with the depth of the Mystic River being such that any ship from a whaler to a sailboat could pass through its convenient waters with relative ease. With factors such as they were, ships did begin to pass—and continue to do so to this day.

Mystic is still one of the most charming tourist ports on the Atlantic Seaboard, with pleasure vessels and charter ships leaving the harbor on an hourly basis during the peak season. At its height, it serviced one of the largest commercial fishing fleets in the United States, and lobster trawlers still call the port home. In general, however, Mystic has evolved from a center of commercialism to one of tourism and maritime education. The Mystic Seaport Museum keeps several ships on hand for educational purposes. Ships such as the *Joseph Conrad*, the *Annie*, and the *Charles W. Morgan* have, at one time or another, educated the masses on historic maritime activity.

The area is rich in seafaring history as well. Aside from its early historic contribution to early American naval services, Mystic was once harbor to the infamous slave ship *La Amistad*. Today, that heritage is kept alive by a replica of the ship that, despite some financial difficulties, still calls Mystic's port home. This—coupled with ships ranging from pleasure craft, to long-distance jolly boats, to race-winning clippers—gives Mystic a seafaring flavor that is rivaled in few places in the United States. The following ships, schooners, and sailboats are just a small sample of the over 400 craft that make up the oceanic fleet of Mystic harbor today.

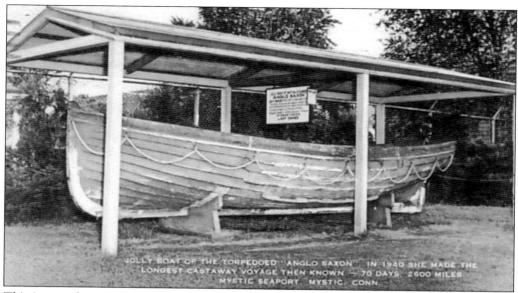

This image, from 1944, shows the infamous jolly boat of the doomed freighter *Anglo Saxon*. The ship, which was carrying coal under an Australian flag when she was sunk by a U-boat during World War II, never came close to Mystic. Her jolly boat, however, became property of the Mystic Seaport Museum after a 70-day, 2,700-mile voyage to the Bahamas that saw only two of the ship's 41 crew members survive. The Canadian Lady Eunice Oakes purchased the boat after her journey and donated her to the museum, where the boat stayed until returned to the British in 1990.

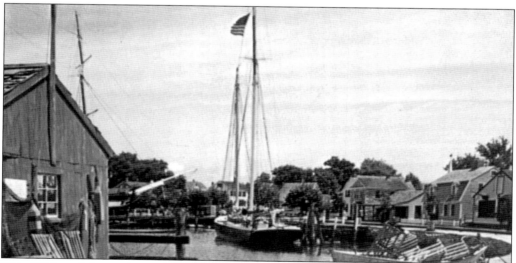

This 1960 card shows the early schooner *Australia*, owned by Mystic Seaport. The back of the card reads: "The "AUSTRALIA" [*sic*] lies at her berth, alongside the seawall behind the Seaport Street. A typical early coasting schooner, she holds the lowest registry number—No. 25—of any merchant vessel afloat in the United States." The *Australia* was built in 1862 on Long Island. Although initially named *Ella Alida*, the ship was renamed *Alida* and saw her greatest service during the Civil War, serving as a Confederate blockade-runner until her capture and auction by the Union.

This card, postmarked October 23, 1912, features one Capt. Asgood Gilbert's lighter (a type of workboat). "Captain Asgood" is assumed to be Osgood Gilbert, brother to shipbuilder Mark Gilbert. The Gilbert brothers ran a shipyard in Mystic and built the Gilbert Block on West Main Street, although they soon gained a reputation for unseaworthy vessels. Lighters are shallow drift boats used to load and unload bigger ships in harbors that are not big enough to justify multiple piers. The ships are difficult to handle, usually in a confined space, and are thus only operated by the most experienced of sea captains. Addressed to a Mrs. D.P. Loetwood of 404 West 115th Street in New York (now a part of Columbia University's campus), the card relates a son's lamentation about having to leave Mystic for better business opportunities.

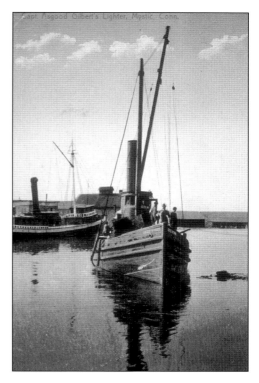

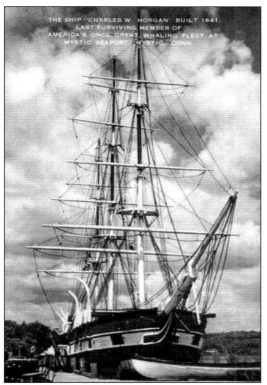

Whaling was one of the largest industries in Mystic and the United States. Shrinking harvests and demand due to alternative energy sources, however, led to many ships being repurposed for other means by the start of the Great Depression. One such ship was the *Charles W. Morgan*, shown standing proudly in Mystic River in this 1950 postcard. On her maiden voyage in 1841, the *Charles W. Morgan* was at sea for over three years, harvesting almost 60 whales with a total market value of over $50,000, or close to $1.3 million today. The caption reads, "The ship 'Charles W. Morgan' built 1841, last surviving member of America's once great whaling fleet at Mystic Seaport, Mystic Conn." The ship now serves as an educational vessel.

Seen here is the *Dorothy A. Parsons*, one of only three Chesapeake Bay log–built bugeyes remaining in the United States. She was built in 1901 and used primarily for fishing, oystering, and crabbing. Oyster boats are forbidden, by maritime law, to have an engine, but the captains of these ships devised a solution: instead of installing a motor on the vessel, the clever seamen would build a small boat to tow behind the craft. This craft would have a motor and could, when needed, push the primary ship. She was named after Capt. Dorothy Parsons, an Army Corps nurse from Portsmouth, New Hampshire, who served in both the North African and European (Italy) theaters of World War II. She is 84 feet long, the mast is longer than the boat itself, and the vessel is harbored today at the Piney Point Lighthouse museum on St. George's Island in Maryland.

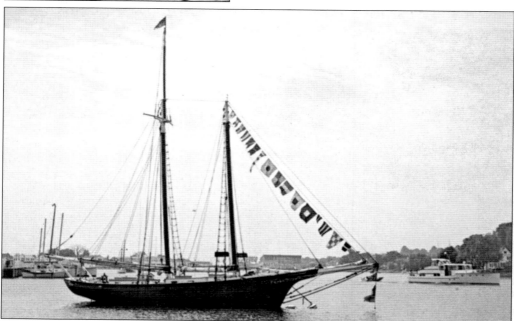

Built in 1866 by Palmer Boatyards, the *Emma C. Berry* ranks today as one of the oldest surviving wooden fishing smacks in the Atlantic fleet. Restored in 1971, she stands as one of the earliest landmarks to livewell fishing boats in the United States. Although *Emma C. Berry* no longer fishes, the Mystic Seaport Museum still puts her to use, as both a museum ship and an educational vessel. The ship made a trip under the power of her own sails down through Fishers Island Sound in 1992, the first time she had done so in 105 years.

The *Emma C. Berry* stands today not only as a museum ship for Mystic Seaport but also as a National Historic Landmark. On the historic landmark form, it states that "the sloop smack Emma C. Berry is the last known surviving American smack." After being abandoned, she underwent an extensive renovation at the caring hands of the Mystic Seaport between 1969 and 1971, which included the restoration of her wet well, replacement of rotted timbers, and conversion to a sloop. The cabin and deck were restored between 1987 and 1988, and new plans were created to show her newly crafted state. Shown here through the window of one of the many buildings at the Mystic Seaport Museum, she stands today as a call back to the earliest days of the American Atlantic fishing fleet.

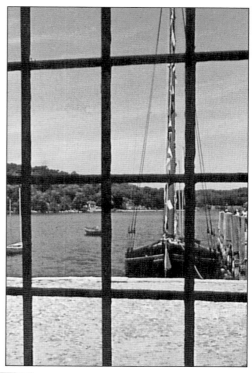

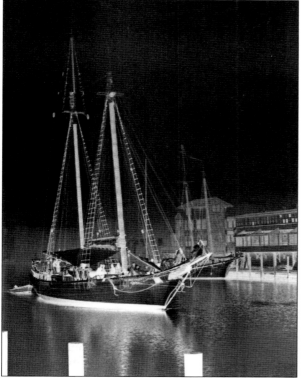

The transient nature of Mystic River is never more apparent than during a visit by the American-flagged vessel *Harvey Gamage*, a gaff-rigged topsail schooner homeported in Portland, Maine. She is 131 feet long, with a sail height of 91 feet and a sail area of 4,200 square feet. She is not solely powered by sails, however: the *Harvey Gamage* houses a 225-horsepower diesel engine. The ship, which sailed to Cuba in celebration of renewed ties with the United States in 2016, was photographed for this postcard by Nelson Holt, a local Mystic photographer. The owners of the ship plan to use her for several educational trips to the island nation throughout 2017. One such trip currently has her stationed in Cuban waters for the rest of 2017.

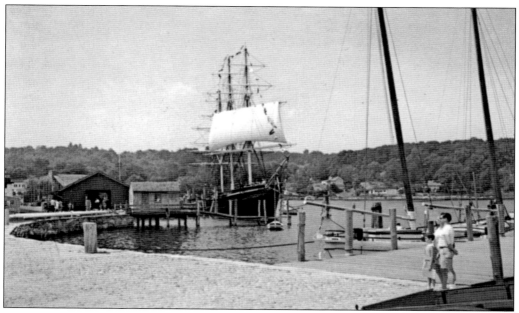

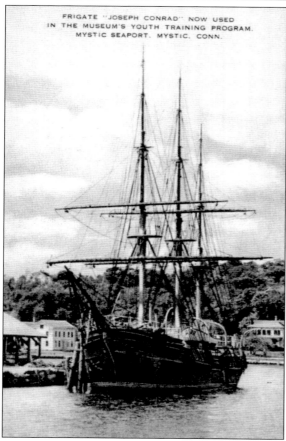

While it may have begun life as the *Georg Stage*, the Danish-manufactured *Joseph Conrad* is one of the crown jewels of the Mystic Seaport Museum fleet. Built in 1882, this iron-hulled beauty led a rather transient life, first as a state-owned Danish vessel, then a private British yacht, before being saved from salvage and renamed after the seafaring author Joseph Conrad. In 1936, a gasoline engine was added, although the ship had seen little sailing action at the time of this photograph in 1950.

The life of the *Joseph Conrad* is complex, even for a ship. Aside from the aforementioned name change, she sailed around the world under the eye of Australian sailor and author Alan Villiers. With little but a crew of cabin boys and inexperienced sailors, Villiers took the ship on a two-year, 57,000-mile trip around the globe, one that started and ended, in triumph, in New York City. Although the trip left Villiers bankrupt, he did manage to pen three novels based on his adventures.

With a view of its upper rigging, shown here around 1990, the history of the famed *Joseph Conrad* is concluded. After Villiers filed for bankruptcy, he was forced to sell the ship to grocery titan Huntington Hartford, who did little with the ship during the war years of 1939–1945. She was laid up for two years after World War II, and the Mystic Seaport finally recommissioned her as a training and museum ship in 1947. The *Joseph Conrad* serves in that role to this day, bringing joy to museum visitors and training opportunities to young would-be sailors.

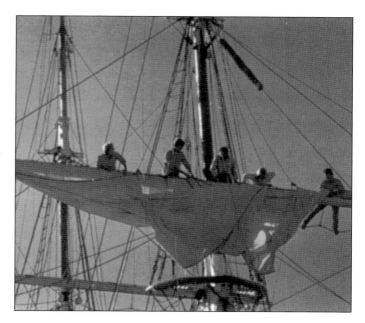

The pride and joy of the museum fleet, the whaler *Charles W. Morgan*, appears to be holding court with a group of small vessels surrounding it in this tourism postcard. The back of the postcard reads, "Mystic, Connecticut. Historically a leading seaport in the area, the story of Mystic's nautical connection is told at the Mystic Seaport, the world's largest maritime museum, which has preserved several sailing ships (shown is the whaler Charles W. Morgan) and historic seaport buildings."

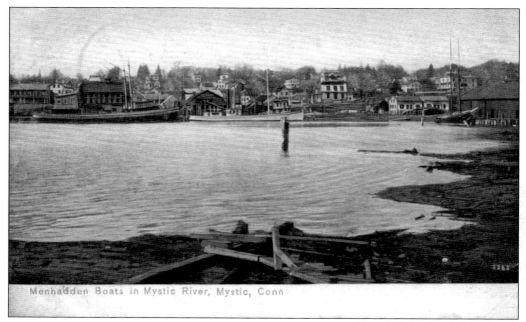

Menhadden Boats in Mystic River, Mystic, Conn

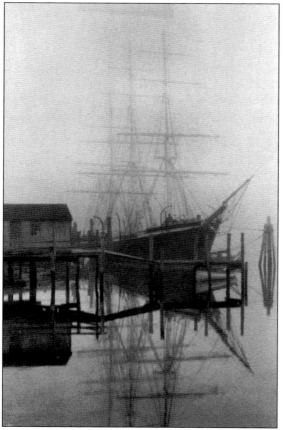

Lined up along the shore in this 1907 artist's postcard of Mystic Seaport are what are known as menhaden boats. The name does not come from the owner or the style of the boat; rather, menhaden boats are fishing trawlers who trawled up and down the coast for a breed of fish called the Atlantic menhaden. A small, oily, plentiful fish, the menhaden are valued not for their food value but rather for their value in providing oil for fish oil supplements (rich in Omega-3) and for their commercial use in both animal feed and, of all things, lipstick. The front of the card reads, "Menhadden boats in Mystic River, Mystic, Conn."

As if harkening back to the ships of the Atlantic fleet that disappeared before it, the iron ship *Joseph Conrad* appears as a ghost in the mist in this classic 1979 view of the Mystic River, 32 years after an act of Congress signed by Pres. Harry S. Truman transferred ownership of the ship to the Mystic Seaport. Today, she is used only as a stationary educational exhibit for visitors to the Mystic Seaport to learn from.

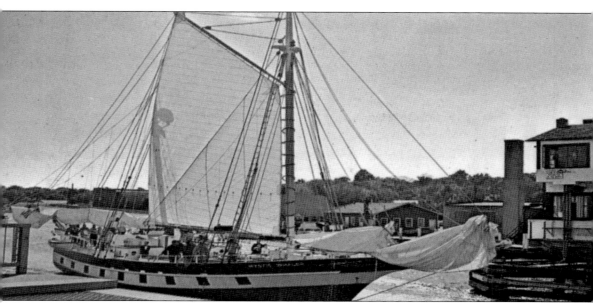

Standing proudly in port is the *Charles W. Morgan*. This card, published by the Mystic Seaport Museum, shows the *Morgan* before her 38th voyage. The *Charles W. Morgan* is a square-rigged whaling ship that carried a fleet of small whaleboats that would scour the Atlantic Seaboard in pursuit of their prey. Whales would be captured and returned to the ship and their blubber would be rendered to thousands of gallons of oil right there on deck.

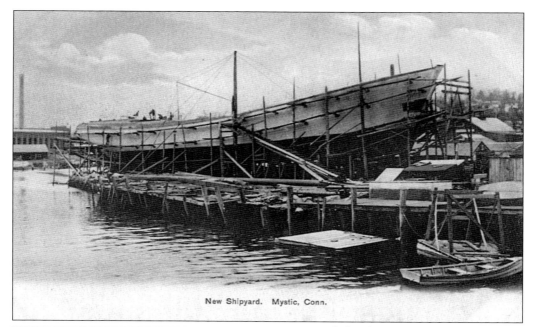

New Shipyard. Mystic, Conn.

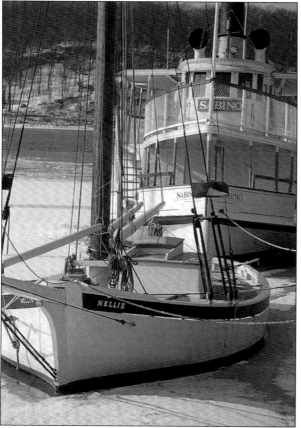

Likely taken sometime between 1915 and 1920, this postcard view looks north from Pistol Point, on the eastern side of the mouth of the Mystic River. The photographer was probably at the Pendleton Brothers' shipyard, which operated from 1916 to 1920 and produced two four-masted schooners during World War I. To the left of the ship being built, the powerhouse, which provided the electricity for the trolleys, can be seen just across the river on the west side.

Featured here along the beautiful brilliance of the winter ice on the Mystic River are the oyster sloop *Nellie* and the wooden, coal-fired ferry *Sabino*. The former was built in 1891 and has spent most of her life dredging natural oyster beds along the Atlantic coast. She worked in this capacity until joining the seaport in 1964. Built in 1908, the latter is the oldest wooden, coal-fired ferry still in operation. Purchased as a working boat by the museum in 1973, she was named a National Historic Landmark in 1992.

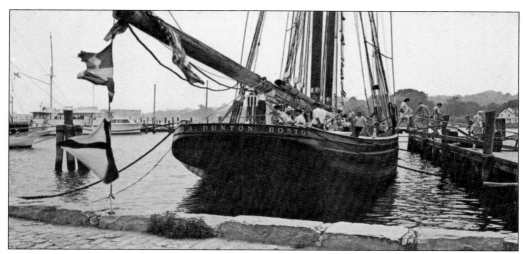

Shown here at dock is the fishing schooner known as the *L.A. Dunton*. Launched on March 23, 1921, in Essex, Massachusetts, she is one of the four flagships of the Mystic Seaport. She was built at the request of Capt. Felix Hogan by famed shipbuilder Thomas F. McManus. Measuring 121 feet long, she served as a home base, processing plant, and transport vessel for generations of Atlantic fishermen. The ship was purchased and restored by the Mystic Seaport in 1963, and in 1993 was named to the National Register of Historic Places.

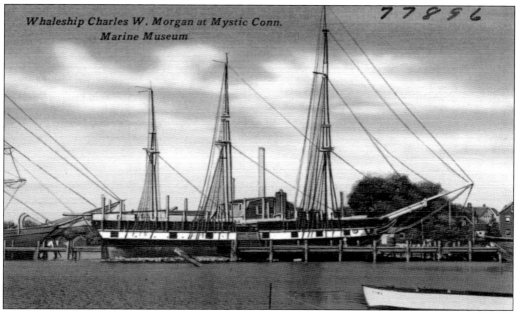

With the small boat *Finn* in the foreground, this image shows the *Charles W. Morgan* under renovation in the Mystic Seaport. The front of the card reads, "Whaleship Charles W. Morgan at Mystic Conn. Marine Museum." The *Charles W. Morgan* spent most of her career harvesting blubber from whales for oil. She harvested her catch in a range stretching from Alaska's Kodiak Islands to Ecuador's Galapagos Islands, where renowned scientist Charles Darwin conducted the base of his research that would lead to his theory of evolution.

The ships at the Mystic Seaport will always hold a special enticement for both young and old alike. This Book and Tackle postcard from the 1980s reads, "At Mystic Seaport in Connecticut, visitors view the figurehead of the *Joseph Conrad*, formerly the Danish Training Ship *Georg Stage*. The square-rigged vessel circumnavigated the world under command of Captain Alan Villiers. The *Joseph Conrad* is now part of the youth training program at Mystic."

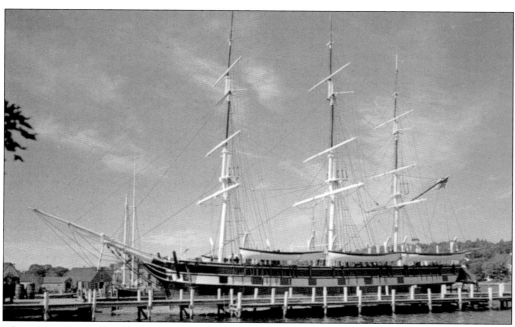

This 1945 postcard by Tichnor Brothers shows the *Charles W. Morgan* in dock at Mystic Seaport. After sailing with over 1,000 sailors in her lifetime (while bringing home 54,483 barrels of sperm and whale oil and over 150,000 pounds of whalebone), she survived 37 voyages, ice storms in the South Atlantic, and even a cannibal attack! After nearly burning to pieces in 1924, she underwent several renovations and is now the jewel in the Mystic Seaport fleet.

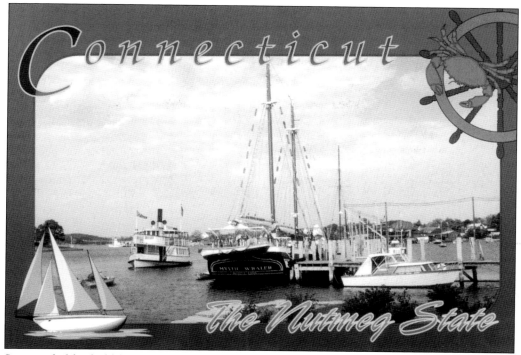

Surrounded by bold letters that declare Connecticut "The Nutmeg State," the *Mystic Whaler* can be seen playing host to several seafaring souls. One of the last cards published by the Book and Tackle store, the photograph (which also includes a view of the Mystic Seaport ferry *Sabino*) was taken by Bernard Ludwig Gordon. She was built in Tarpon Springs, Florida, in 1967 and was completely restored in Providence in 1993. The *Mystic Whaler* conducts cruises, special events, and meal cruises with some of the finest lobster dinners on the East Coast. She measures 107 feet and has six restrooms.

After the 1924 fire, the *Charles W. Morgan* was repaired in New Bedford, Connecticut, and later sent to Mystic in 1941. Its preservation was important, seeing as it was and is the last surviving wooden whaler in the world. This postcard is special because it shows the old whaler's trip up the Mystic River to its final home. The caption on the front of the card reads "The 'Charles W. Morgan' coming up the Lower Mystic River. 11:00 A.M., November 8th , 1941."

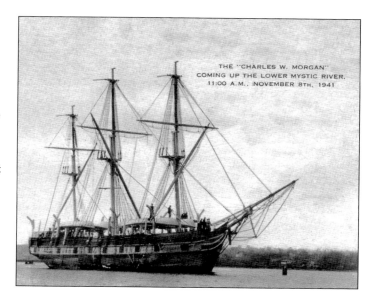

THE "CHARLES W. MORGAN" COMING UP THE LOWER MYSTIC RIVER. 11:00 A.M., NOVEMBER 8TH, 1941

Although the names are difficult to make out (save for *Fatima*), the serene beauty of the Mystic Seaport shown in this art postcard cannot be denied. While the name of the artist is not presented anywhere on the card, it is fair to assume that it is someone with a close connection to the area, as such a deft eye for the beauty of the seaport could only be had by someone familiar with the area.

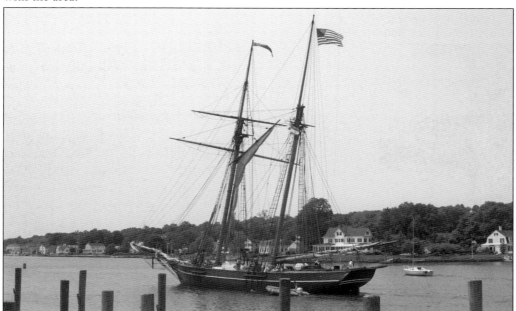

Although the original never called Mystic home, the history of *La Amistad* and Mystic Seaport are special. After the famed 1839 trial, which saw several captive Africans freed after a long struggle, the original ship was sold for salvage and lost to time. A replica, however, called the seaport home for years, albeit in private hands. Mystic still holds a special place in *La Amistad* lore; Steven Spielberg used the town to film several scenes of his film adaptation of the *Amistad* affair.

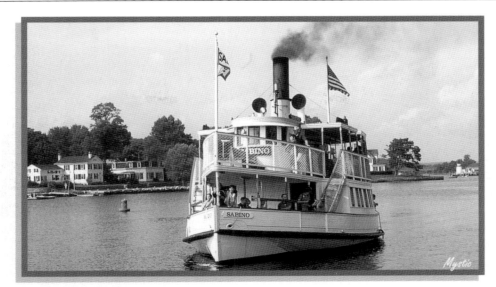

Connecticut Shoreline

This is a rather new card used to promote the tourism industry of Mystic using the aforementioned *Sabino*. The back of the card reads, "Visit downtown Mystic and Old Mistick Village: Stores, restaurants, gift shops, museum & history. Visit Mystic Seaport and take a ride on the Mystic River on the steamboat "Sabino". [*sic*] Go past the downtown drawbridge. Mystic & Shoreline Visitor Information 860-536-1641 Greater Mystic Chamber of Commerce 860-572-9578."

With a small sailboat in the foreground, both the schooner *Brilliant* and the Mystic Seaport Light keep watch over the seaport in this artist's rendition. In one of many postcards in this series, the beautiful watercolors were painted by local Mystic artist Lizbeth McGee. This particular image is entitled *Seaport Setting: Mystic Seaport, Mystic, CT* and is part of her Views & Vignettes series, which carries the tagline "Capture Beauty Timelessly."

Although the Arctic exploration schooner *Bowdoin* no longer calls Mystic home, her history is nonetheless one of pride and maritime excellence. The ship started her life as a scientific exploration vessel before being commissioned into service during World War II—one of the few sail-powered ships to be utilized thus. Donated to Mystic Seaport, she spent several years broken and in a state of neglect before being purchased and relocated to Maine, where she is now the state ship of Maine as well as a National Historic Landmark.

Like the *Bowdoin*, the schooner *Brilliant* did proud service to her country during World War II. Built originally as a racing ship (one that set records for the fastest traversing of the Atlantic in 1933), she was donated to the Coast Guard in 1942 to hunt for Axis submarines along the Atlantic Seaboard. After her wartime efforts, she was used as a racing vessel until her donation in 1953 to Mystic Seaport, where she now works as an offshore classroom vessel.

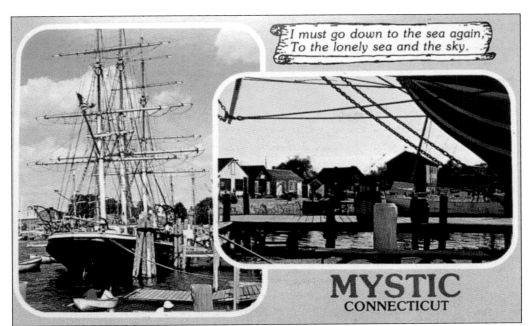

I must go down to the sea again,
To the lonely sea and the sky.

MYSTIC
CONNECTICUT

This foldout packet of several postcards gives the owner a view of all the delightful sights and sounds of Mystic Seaport. The *Joseph Conrad* graces the cover, and inside are six other postcards, which are scattered throughout this volume. Images include *Authentic Old Buildings on Seaport Street*, *Fishtown Chapel*, and *Cobblestoned Seaport Street*.

As if the ship had planned on dropping in for a drink, the back of this pre-1980s postcard reads, "Mystic Seaport: A 19th Century Coastal Village recreated at Mystic, Connecticut. Schaefer's Spouter Tavern and the Charles W. Morgan. The Tavern, located at the head of the Seaport Street, served as an inn, ordinary, and lodge hall for the community. In the background, the Charles W. Morgan last of the wooden whale-ships, is seen at her berth." This card was published by Colourpicture Publishers in Boston.

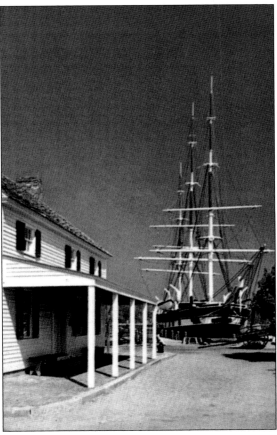

With the Stillman Building looming in the background, the racing sloop *Annie* can be seen resting in a state of disrepair. The ship was constructed in 1880 by builder David O. Richmond, himself of Mystic. Originally owned by Henry H. Tift, she was used for racing, which was popular at the time for sandbagger sloops. In 1931, she was acquired by the Mystic Seaport Museum, becoming the first museum ship in its fleet. In 2004, she completed an extensive renovation, restoring her to her original shape, and she is now part of the museum fleet.

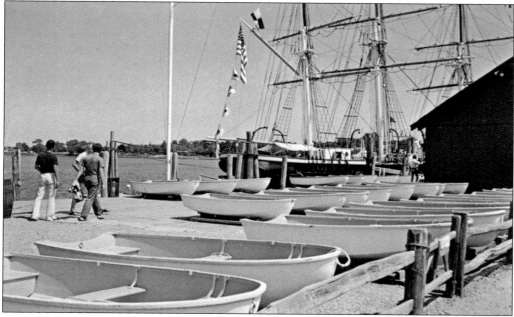

The sailing at Mystic presses on, as does the learning. This undated postcard shows several recently manufactured boats in the shadow of the *Joseph Conrad*. The Mystic Seaport Museum offers sailing lessons and camps throughout the year, and several local private businesses do the same. The manufacture of craft still happens at Mystic, even as the maritime game itself evolves to fit the needs of a new economy and a new world.

Two

COASTAL CONSTRUCTION
HISTORICAL BUILDINGS AND
ARCHITECTURE OF MYSTIC

One of the more charming features of Mystic is the astonishing variety of historic structures that dot the landscape. The replica seaside village at the Mystic Seaport itself is a sight to behold, and, almost a hundred years later, the Mystic River Bascule Bridge stands as a marvel of engineering. From specialty buildings to some of the finest examples of early New England architecture, there is very little about the Mystic community that can be described as cookie-cutter.

Historic character is first seen in the downtown village. Aside from the bridge, there are historic buildings that serve as businesses, homes hundreds of years old, a downtown bank of Georgian-Colonial architecture, fishing piers redesigned to suit the needs of modern seafarers, and churches that have weathered mergers and storms. Zoning regulations more sparse than typically encountered enabled the towns on either side of the Mystic River Bascule Bridge, which are actually parts of Groton and Stonington (but operate independently as far as business operations go) to develop beautifully. Most buildings could be, and were repurposed for different things based on the needs of the community. This holds true even today, as the Mystic Seaport has made it a point to repurpose older buildings and ships for educational purposes, and even the former Rossie Velvet Mill on Greenmanville Avenue has found new life as the Mystic Seaport Museum's G.W. Blunt White Library.

This joyful history of reclaiming and remodeling does not compromise Mystic's history, however. The families and businessmen that occupy Mystic today have been of the same ilk for more than a century, and have maintained a standard of restoration in keeping with the times in which many of the historic homes were built. The delicate balance of reuse and repurposing with restoration and preservation efforts is as much a part of Mystic's charm and resilience as the bridge or the sea is. This chapter displays the homes, buildings, and businesses that make Mystic unique, and illustrates how these forms allow Mystic to continue to serve those who call it home.

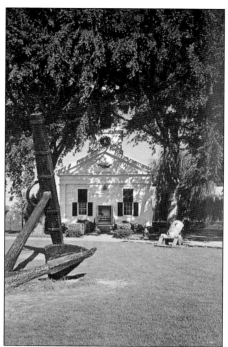

This 1960s view shows what was then known as the Aloha Meetinghouse, a nondenominational church for the various faiths of the seafarers that came through Mystic. This history of the church goes back much farther than that. It began life as the Greenmanville Seventh-day Baptist Church in 1851. The church was built from contributions primarily from the Fish and Greenman families. This was a congregation that observed the Sabbath on Saturday and met for nearly 50 years before closing in 1904. The building was eventually purchased by Mystic Seaport in 1955 (after spending time as a private residence and as apartments) and now stands, renovated, as a museum church.

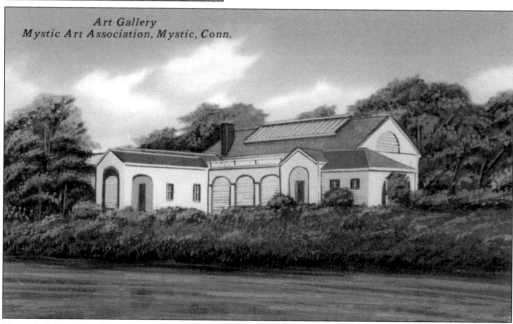

Art Gallery
Mystic Art Association, Mystic, Conn.

Founded in 1913, the Mystic Museum of Art started its life under the guidance of American tonalist and impressionist Charles Harold Davis. Although it started life as a collective for artists to share works and ideas, it soon evolved into a museum in its own right with the first donation of art in 1933. Over time, the museum and the association have evolved into an educational nonprofit organization. This card illustrates a glorious depiction of its appearance in 1931, two years before its first permanent collection.

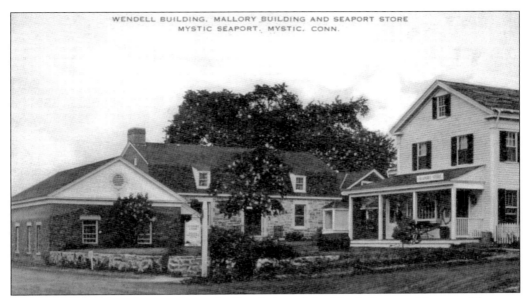

WENDELL BUILDING. MALLORY BUILDING AND SEAPORT STORE
MYSTIC SEAPORT. MYSTIC. CONN.

Several buildings have long made up the foundation of the Mystic Seaport Museum. They are, from left to right, the Newell Building, the Mallory Building, and the Seaport Store. The former Seaport Store is just that: a market owned by the seaport and used to sell gifts. The Wendell Building serves as a gallery for ships' heads and other wood art from boats. The Mallory Building is one of three to currently carry the Mallory name. It was originally the membership building and now features the butterfly gardens in its front yard.

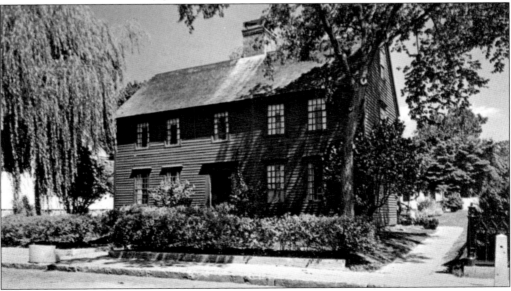

The Buckingham House, originally built in Saybrook, was bought by the Hall family in 1833. This traditional-style farmhouse, while well-equipped for its time, has none of the modern amenities people have come to expect in the 21st century. When the house faced destruction, the Mystic Seaport agreed to take it in 1951, using a barge to move it to its current location at the seaport. Today, demonstrations show a life past, as well as open-fire cooking, quilting, and dressmaking.

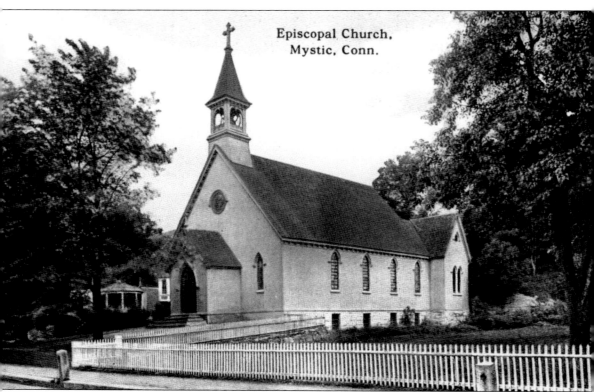

Episcopal Church,
Mystic, Conn.

St. Mark's Episcopal Church started life as a mission 1859. In 1865, the congregation raised the funds for the current Pearl Street location; the gargantuan amount of $9,000 was paid off by 1873. The church would lose its status as a parish at least three times in the next 100 years, falling back into mission status until the congregation raised the funds to pay off debt owed to the diocese. An education wing was added in 1962, and today, the church stands as a testament to the dedication of its parishioners.

The Boardman School was one of many early one-room schoolhouses in the state of Connecticut. Although nobody knows the exact date, it is thought that the school came into existence in 1765, in Preston. The school, named for the family whose land it occupied, became part of Griswold when it became a town in 1815. The structure, along with its collection of early educational relics, was moved to Mystic Seaport in 1949.

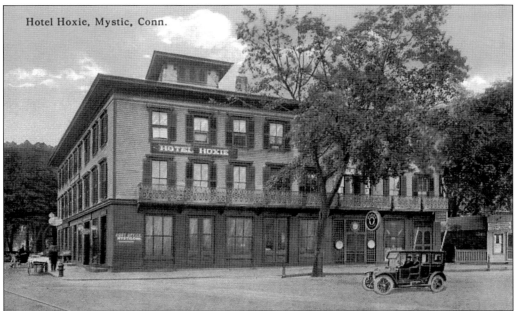

Upon the U.S. Hotel's demise in an 1858 fire, the Hoxie House was built in the same location in 1860. Pictured here in 1917 as the Hoxie House Hotel, aesthetically pleasing Doric architecture stands prominently at the corner of East Main and Cottrell Streets. It was a mixed-use building, with commercial activity on the main floor and lodgings on the second and third. After many fires, it stands today as the Whaler's Inn, which has served tourists, celebrities, and presidents.

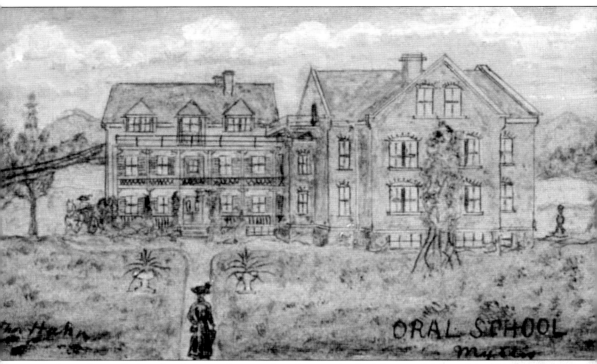

A replica painting by famous Connecticut impressionist Thomas Hahn, this 1911 postcard shows the Mystic Oral School a mere 10 years before it would become a state institution. It was originally opened in 1869 in Ledyard (formerly Quakertown) by Zerah Whipple to teach the method of communication that her grandfather invented to help her uncle after he became deaf following a bout with scarlet fever (a common consequence in that time), thus meeting an important need.

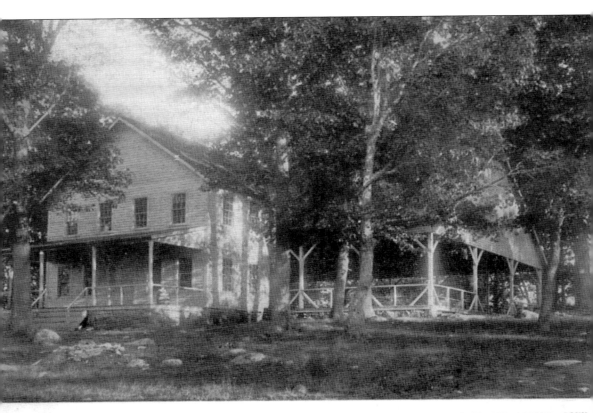

PEACE TEMPLE, MYSTIC, CONN. PUB. BY H. D. UTLEY, NEW LONDON, CONN.

The Peace Temple was a Mystic meeting site built in 1896 by the antiwar group Universal Peace Union (UPU), which was originally founded in 1866 in Providence, Rhode Island, as an offshoot of the American Peace Society. In 1914, it became part of all-girls Camp Mystic, founded by famed explorer Mary Jobe Akeley. This card, while never mailed, was used for a message, which reads, "Dear P.C.F. I hope you will like these cards call again soon. Your card's was very pretty. K.M.C." This card was published by H.D. Utley of New London.

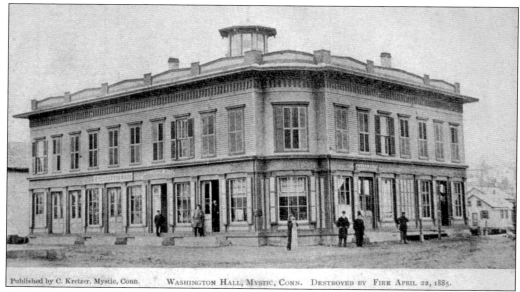

While the lot is currently home to Mystical Toys, one of the area's favorite stores, the location that once housed Washington Hall has a sordid, flame-ridden history. Washington Hall, pictured on this card, was burned down in 1885, only to be replaced with an opera house that burned down in 1900. The block was repurposed as a theater and a dry goods store that managed to stand until 1960, when it was consumed by flames. The dry goods store reopened and stayed in business until 1989. Mystical Toys moved in and has occupied the site since 1999.

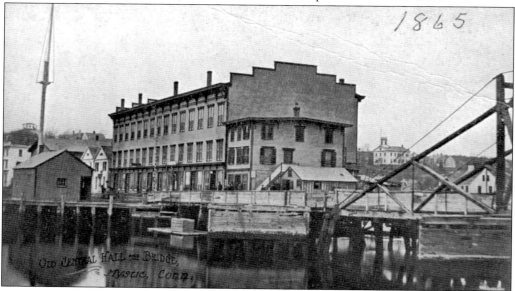

This 1865 photograph of Old Central Hall and the Liberty Pole in West Mystic (where the Liberty Pole was from 1872 to 1876) became a postcard shortly after private postcards were popularized in 1898. During its 160 years, it burned twice, in 1910 and March 2000. It housed many shops, served as the Freemasons' meeting space for a time, and even had an indoor roller-skating rink in 1882. Its former space on West Main Street is being redeveloped. In the upper left, the Mystic Academy can be seen in the distance. (Courtesy of Groton Public Library.)

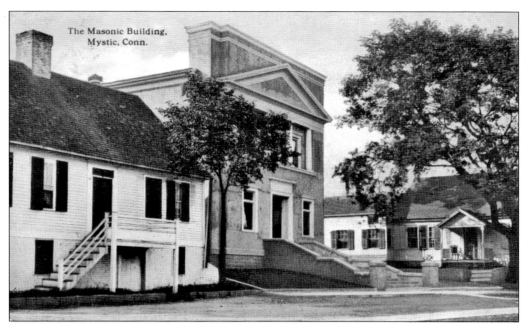

The Masonic Temple was constructed on Gravel Street in 1911 after the meeting space in Old Central Hall burned down. The Freemasons were first established in Portersville (East Mystic) in 1825 and in Mystic River (West Mystic) in 1869, but they merged in 1891 as Charity & Relief Lodge No. 72, which met here. Today, they are Coastal No. 57. Across the street was the Mystic Hook & Ladder Co., where many charitable Freemasons volunteered. The building at left is now the First Church of Christ, Scientist (Boston-based and established in 1899). (Courtesy of Groton Public Library.)

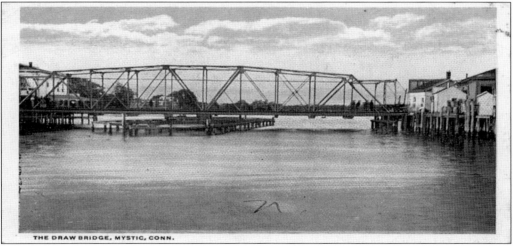

This 1915–1922 postcard shows the steel through truss swing bridge over the Mystic River, the fourth incarnation of the bridge. By this point in history, the "Trunk Line" legislation had been passed through the Connecticut General Assembly, which gave the state highway department responsibility for the maintenance of major roads in the state, which eventually, along with the Federal Aid Road Act of 1916, led to the improvement of the bridge. This gave rise to the fifth and, as yet, final incarnation of the bridge—the Mystic River Bascule Bridge of 1922.

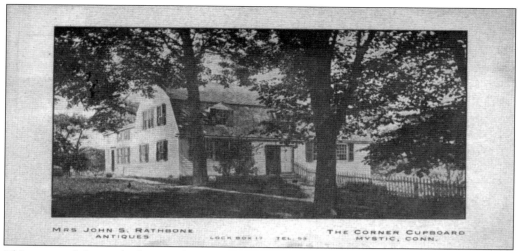

This postcard shows the home of Arline P. Rathbone, who ran an antique store known as the Corner Cupboard out of the home that her husband, John S. Rathbone, built her in 1900 at 8 Park Place, Mystic. This card was mailed on March 8, 1910, to Topeka, Kansas, with the message "Thanks for your kind invitation. I hope some time to visit Topeka but not at present. Hard to leave the antiques, you will know the old house where we visited your mother and the rest of the family. EBH."

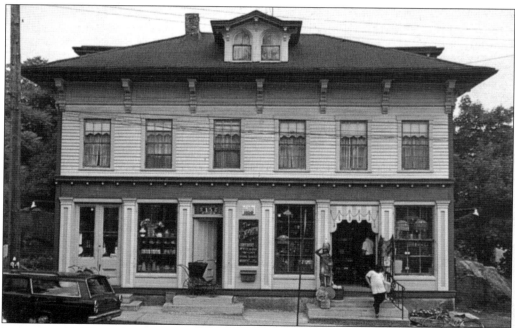

Located at 15 Water Street, the Victorian Ashby House was built in 1859 by Isaac Randall and Dwight Ashby. During the Civil War, it served as a post office and general store. In 1965, it became the legendary Emporium, an eclectic souvenir and antique shop, after it was purchased from local actor Lee Howard and artist Paul White, who restored the building. The Emporium closed its doors in 2013, but rumors abound in town that it will be revived, albeit at a new location.

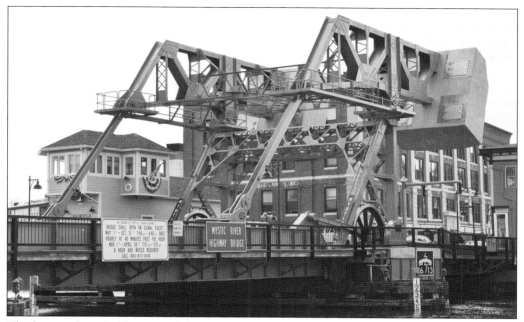

The long and storied history of the Mystic River Bascule Bridge is covered in a later chapter, but suffice it to say, it "raised" American drawbridge technology to new heights in the early 1900s. It was the first type of its kind in the United States when it was built in 1922. The bridge is 48 feet wide, 223 feet long, and allows any and every height of ship into Mystic Harbor. (Courtesy of Ellery Twining.)

The roadway on the Mystic River Bascule Bridge is not made of concrete, which would make it too heavy to rise. Instead, the roadbed was fashioned with grating that is light enough so that the bridge can be raised 90 degrees in less than 40 seconds. The bridge construction finished the state highway department's plans to renovate coastal Route 1, which was the most vital "Trunk Line" highway in the state of Connecticut in the 1920s. (Courtesy of Ellery Twining.)

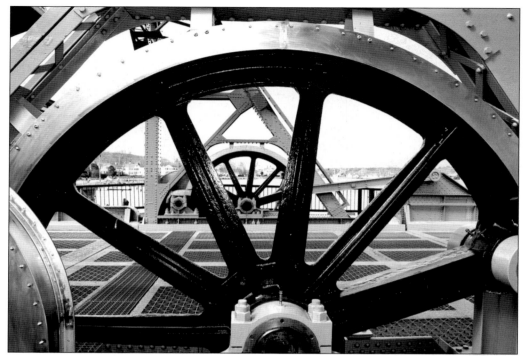

This is one of the two greased wheels that allow the Mystic River Bascule Bridge connecting East and West Main Streets to be raised up and down. The bridge is operated every hour at 40 past the hour or on demand from sunup to sundown between May and October, and by demand during the rest of the year. These wheels are inspected every 100 openings during the tourist season and once every two weeks during the less busy winter months. (Courtesy of Ellery Twining.)

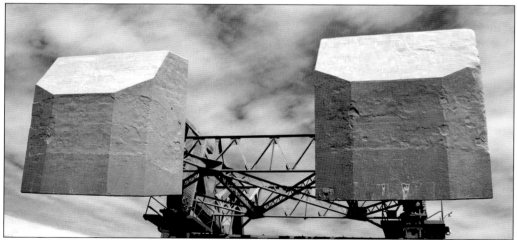

Weighing in at just under 230 short tons, these huge concrete counterweights provide the distribution needed to both raise and keep the Mystic River Bascule Bridge in place when it is in the open position. Until 1928, the bridge carried not only cars and horses but also trolleys from the Groton and Stonington Street Railway that serviced Mystic. (Courtesy of Ellery Twining.)

The Mystic River Bascule Bridge is not only for vehicular and seafaring traffic, however. Although the bridge services an average of 11,800 cars a day (not to mention countless boats), it is also responsible for a great deal of the area's foot traffic from one side of the river to the next. Although the guardrails only stand waist high, there is really no danger of falling and no need to worry, unless a person cannot swim—or has a phone in his pocket! (Courtesy of Ellery Twining.)

The bridge is currently in its fifth incarnation. A plaque on the side of the bridge, pictured on this postcard, reads, "At This Crossing: 1819 Mystic Bridge Co. Wooden Drawbridge. 1854 Henry Latham. Wooden Drawbridge. 1866 A. D. Briggs, Iron Swing Bridge. 1904 Burlin Const. Company. Iron Swing Bridge. 1922. American Bridge Co. Iron Bascule Bridge." Farther down the plaque, the history is described in detail. (Courtesy of Ellery Twining.)

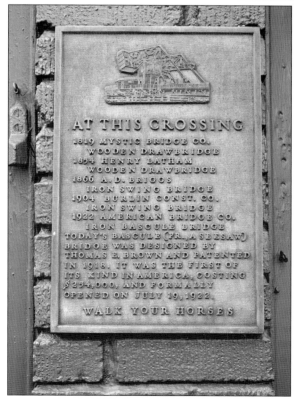

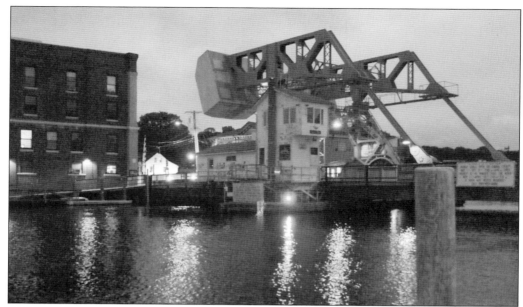

This beautiful image shows the Mystic River Bascule Bridge at night. While Mystic has enough to offer an enjoyable nightlife during the summer months, things are calmer, yet still charming, during the chilly, snowy months of a New England winter. Nonetheless, the bridge is constructed to weather all types of storms, as well as the ghosts said to haunt the area! (Courtesy of Ellery Twining.)

The steeple of the Union Baptist Church, pictured here, has a history that is almost as long and storied as the church's itself. The image here captures the classic beauty of Mystic, all wrapped up in an image that speaks to the promises of whatever higher power the people of Mystic care to call their own. (Courtesy of Ellery Twining.)

Although built in 1811 by Guy Burrows of the local Burrows family, this 126 High Street home would become, a scant five years later, the Tift House, after being purchased by the exceptional local business family, the Tifts, whose sons Henry H. and Nelson (later a captain and boatbuilder in the Confederate navy) founded the cities of Tifton and Albany, Georgia, respectively. The two-story, Greek Revival, five-bay house now stands as a historic residence, listed in the National Register of Historic Places. (Courtesy of Ellery Twining.)

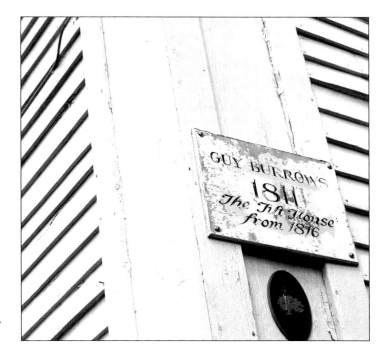

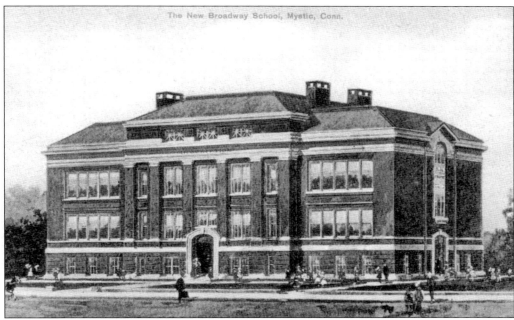

The Broadway School (at the intersection of School and Broadway Streets) is depicted shortly after its opening in this early-1900s postcard. The three-story brick building was constructed across the Mystic River from the Mystic Academy (which was razed and reconstructed in response to the competition posed by the Broadway School). The building stood for decades until the school district consolidated, closing the doors. Today, the structure stands as a renovated 21-unit condominium.

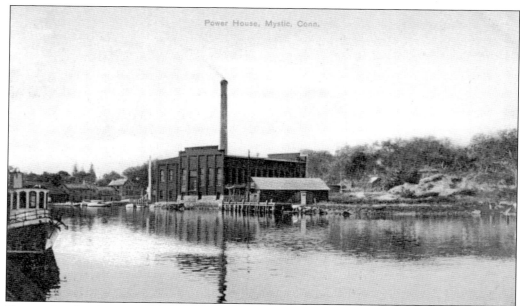

Shown shortly after the start of the trolley in 1905, the powerhouse on the west bank of the Mystic River was used to generate the electricity that moved the Groton and Stonington Street Railway along its route. Situated between the river and Water Street, this building now stands as another set of luxury apartments, pointing to Mystic's new trend of turning old industry into new housing.

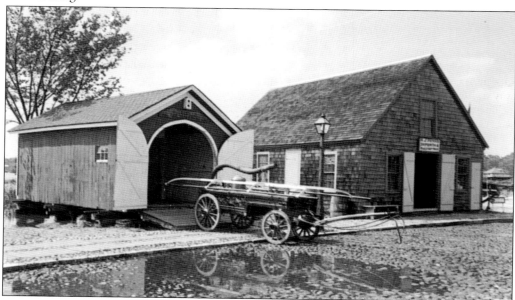

Shown here in the 1950s, well past their heyday, are the horse carriage and buildings from the Old Reliance Fire Company, now housed at Mystic Seaport. The company, which started life as a private one and became part of public services over time, has a history that dates back almost two centuries. The company celebrated its 175th anniversary in 2012. The equipment has improved drastically over time, which has led to fewer catastrophic fires in the last 30 years. The current firehouse is at 295 Car Hill Road in Mystic. (Courtesy of Debbie Hindman.)

Three

LIFE'S A BEACH
PORTRAITS OF THE MYSTIC COAST

The Mystic River, whose name derives from the Mashantucket Pequot word *missi-tuk* (roughly translated as "a river with waves formed by tides or wind"), is not a typical freshwater river, such as, say, the Mississippi River. It is a tidal ribbon of salt water, whose harbor serves as an access to Fishers Island and Block Island Sounds, which flow to and from the vast Atlantic Ocean. As a body of salt water, its ecosystem and environment support a portion of the seafaring way of life, as well as the vibrant tourist industry in southeastern Connecticut.

The river geographically divides the towns of Groton and Stonington. The former, on the west side of the river, manages the affairs of West Mystic and the western portion of Old Mystic (at the top of the river), and is home to Naval Submarine Base New London. The latter, on its eastern shore, serves as the official steward of East Mystic and the eastern portion of Old Mystic. Although a census-designated place by the federal government with its own zip code and post office, Mystic, comprised of the east and west riverside towns, has no independent government of its own.

Mystic lies in the Mistuxet Valley, a portion of southeastern Connecticut famous for its African and glacial rock, remnants of the landmasses that broke apart into continents 175 million years ago and of the glaciers that later collided with the coastline. Almost everywhere one looks in Mystic nature, the rocks can be seen, and the town and its culture were forged around them, infusing its most ancient past into each new modern era, with the Mistuxet Rock or the Wolf's Den at Deans Mill Park, or with the retaining walls used to line the banks of the Mystic River.

Mystic's famously coveted water-views are sought by all, and every year thousands of tourists flock to the quaint coastline to bask in the shimmering sunsets, sail the salty waves, or go fishing. Mystic has a long, picturesque legacy of stunning sea-sights, and this chapter chronicles them.

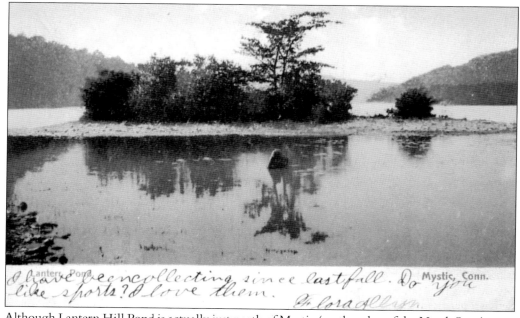

I have been collecting since last fall. Do you like sports? I love them. F?ora Allyn.

Although Lantern Hill Pond is actually just north of Mystic (on the edge of the North Stonington and Ledyard borders), it boasts a history as a picturesque landmark that helped draw tourists to southeastern Connecticut. Fed by Hill Brook, this marshy pond is a local favorite and is just north of the Mashantucket Pequot Reservation and south of the Mashantucket Pequot–owned, world-renowned Foxwoods Resort Casino. The handwriting on the front reads, "I have been collecting since last fall. Do you like sports? I love them. Flora Allyn." This card was published and mailed in 1906.

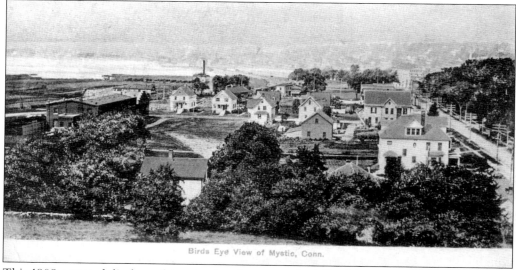

Birds Eye View of Mystic, Conn.

This 1908 postcard displays a historic view from atop the hill of the present-day Inn at Mystic, on the corner of Route 1 and Denison Avenue. To the left, the brick Packer Tar Soap factory can be seen, flanked by train tracks on the south side and a dirt road on the north (which would become Route 1 in 1916). The unpaved Washington Street extends from the right corner of the image, peppered with residential homes and utility poles.

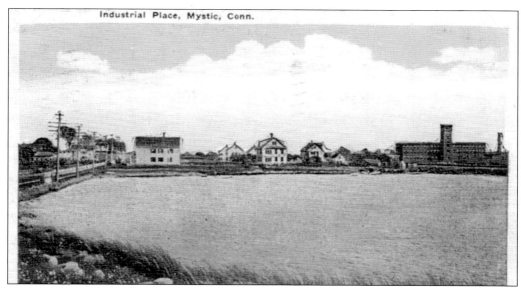

Mystic largely became a place of factories in the late 1800s, but remnants of its manufacturing heritage persisted after the 1920s, when the service economy rose. To the right of this image sits Sondonia Mills, a mere block to the south of US Route 1, which was paved just 13 years prior. Postmarked January 7, 1929, the back reads, "How would you like to be at this place now. Regards, Everett La Lind." It is addressed to Miss Edna Larzelae of 270 Irving Avenue in South Orange, New Jersey.

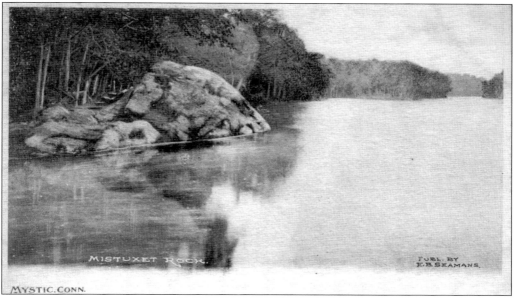

Lying just north of the Deans Mill Reservoir Dam along the west bank is Mistuxet Rock, shown here in this 1901 postcard. Across the road from the Wolf's Den (mentioned in this volume), the rock is part of what was formerly Deans Mill Park, which was closed in 1922 to avoid polluting the reservoir. Mystic sits in the Mistuxet Valley, a portion of Connecticut famous for its copious amounts of African and glacial rock, both of which can be seen in the Deans Mill area.

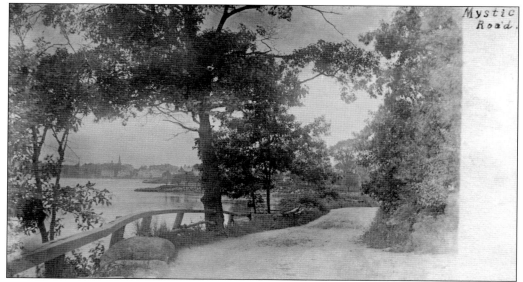

Taken around 1899, this rare photographic postcard offers a quaint glimpse from the east riverside of a distant Baptist Hill, framed with the boughs of tree branches. The silhouette of the Union Baptist Church's steeple can be seen extending from the peak of the town's horizon, gesturing in reverent tribute toward the heavens. Dirt road views like these became history in the early 1900s, as roads began to be paved to make way for automobiles.

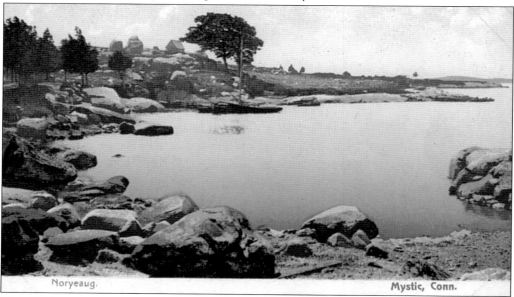

This 1908 view is from the west side of Nauyaug point (misspelled on the card), now called Mason's Point, on the southernmost portion of Mason's Island in Mystic. By 1914, several cottages had been constructed there, and source texts say many of the rocks along the shore had actually been "blasted from the nearby boulders and ledges" by Andrew Mason, who owned and sold lots on the point. This card was mailed on September 10, 1908, from Boston to Cambridge. On it, the sender describes a lobster bake that took place at this very locale sometime in the months prior.

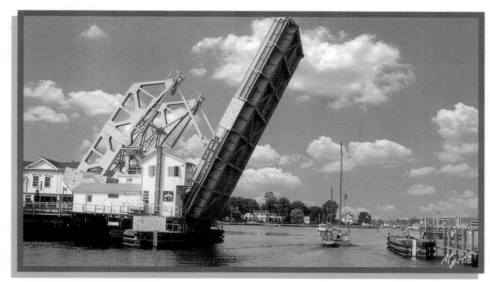

Connecticut Shoreline

This modern card, published by New England Photo, shows the Mystic River Bascule Bridge from the south. The back of the card reads, "Mystic, Connecticut. The town of Mystic was founded in 1654, and quickly rose to prominence as a shipbuilding center during the clipper ship era. Nowadays, Mystic has become known for its quintessential New England charm, as well as its two world class museums: The Mystic Seaport and the Mystic Aquarium & Institute for Exploration. Mystic's beautiful downtown is home to dozen of quaint shops and restaurants, and hosts festivals and events year-round."

Taken from the east (Stonington) side of the river, this image provides a view of Gravel Street. Worth mentioning are the several mainstays of New England Americana in this photograph: the wooden riverside patio/dock, decorated with an ornate entryway to invite visitors off the river; the flagpole, a staple of upper-class houses at the turn of the century; and various styles of homes. The front of the card reads, "Alongshore. Mystic, Ct." (Courtesy of Groton Public Library.)

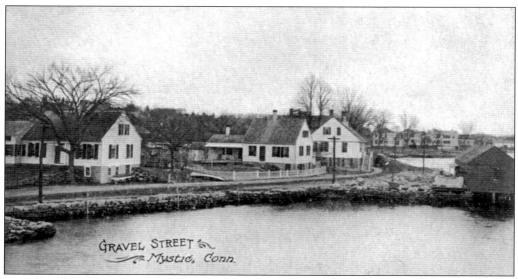

Gravel Street, shown here, is significantly historic for the Mystic area; it boasts some of the earliest examples of classic coastal architecture in America, featuring Cape Cod– and Greek Revival–style homes. To the right in the photograph sits a boathouse, which served the purposes of boat repair, net building, and off-loading catch. Known as Captains Row (for the number of boat captains that would call it home when they were ashore), the area today has been revitalized with an eye towards its seafaring past.

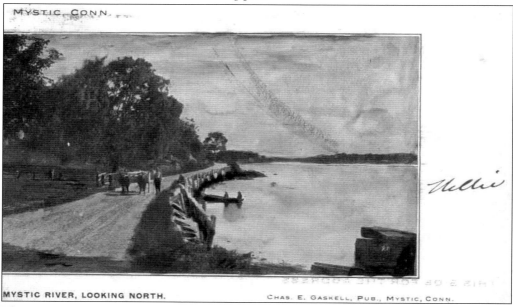

This 1906 postcard provides a view of what is likely River Road, a long, winding, and picturesque street that laces the west bank of the Mystic River and once offered a path to the heart of Mystic for farmers and their wagon teams, like the one seen here. Agriculture was one of the major industries of Mystic long before it became a tourist haven. The card is addressed on the front to "Willie" and reads, "Mystic, Conn. Mystic River, Looking North." It was published by Charles E. Gaskell of Mystic, Connecticut. (Courtesy of Groton Public Library.)

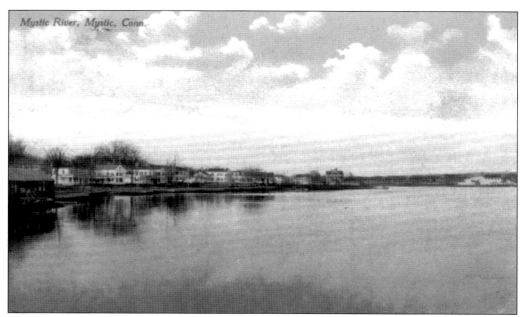

This watercolor postcard from 1918 shows another view of Gravel Street in West Mystic. Mailed on August 26 of the same year, the front of the card reads, "Mystic River, Mystic, Conn." This particular location was a popular ice-skating spot, as depicted in a later chapter. This card, along with several others shown in this volume, is part of the Janet Thompson Collection at the Groton Public Library. (Courtesy of Groton Public Library.)

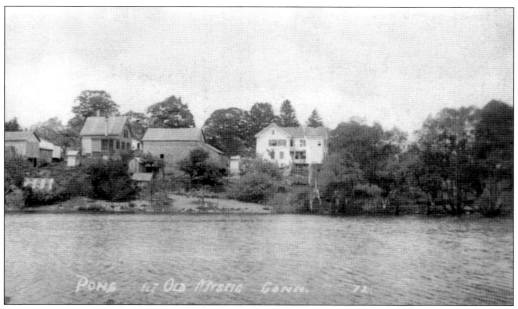

The title of this card reads, "Pond at Old Mystic, Conn. 72." Fishing in many areas, such as the one pictured here, is a popular pastime in Mystic. The Mystic River actually has no closed season for fishing, and many people fish right off the docks to the south of the Mystic River Bascule Bridge or from their boats out on the river. (Courtesy of Groton Public Library.)

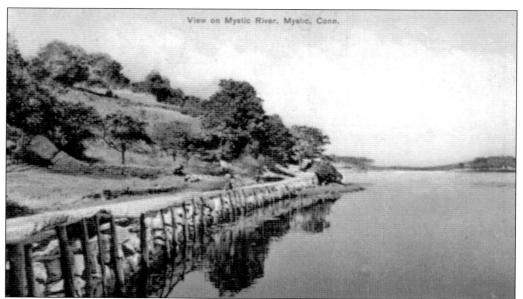

Published by the Rhode Island News Company in 1909, this card provides another view of the wood and rock retaining wall that lined the banks (likely west) of the Mystic River. This card reads, "My dear boy, We are in Mystic. I wonder what you are doing be a good boy. Lovingly, Ma." and is addressed to Frederick Leffingmall, Norwich, Leone, R.F.D. 2. (Courtesy of Groton Public Library.)

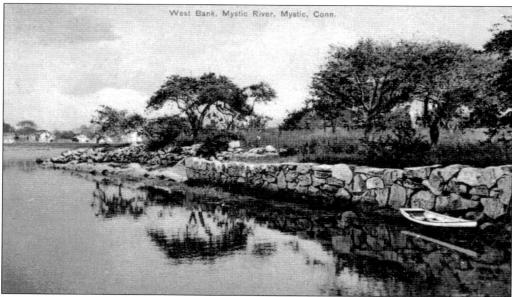

This picturesque card shows another beautiful view looking south along the west bank of the river. This card was postmarked at 5:30 p.m. on August 26, 1909, and reads, "Dear Gussie: Was disappointed that you could not come over for the bridge. This after to Stonington to a small party. Mrs. Mckeccom is next walk by and run over to see us. You are a great changes. Affectionately, Molly D. Gary." It is addressed to Miss Gussie Flint at Boulder Crest, Watch Hill, Rhode Island. (Courtesy of Groton Public Library.)

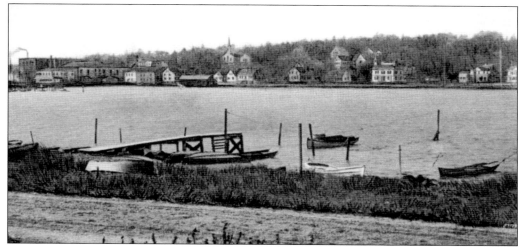

With Union Baptist Church on the hill, this postcard image, taken from the east bank, shows several of the Cape Cod– and Greek Revival–style homes that line Gravel Street on the west bank of the Mystic River. Also shown are several small boats, used by the residents of Mystic for either pleasure fishing or simple jaunts up and down the shore. This card was published by the Mystic Variety Store in 1915. (Courtesy of Groton Public Library.)

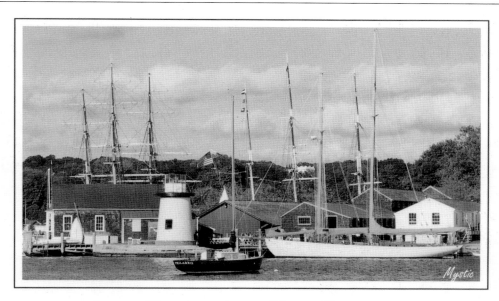

Connecticut Shoreline

This shoreline card shows the *Philabro* in the center, and in the background on the left are the masts of the *Joseph Conrad* beside the *Charles W. Morgan*. The back reads, "The town of Mystic was founded in 1654, and quickly rose to prominence as a shipbuilding center during the clipper ship era. Nowadays, Mystic has become known for its quintessential New England charm, as well as its two world class museums: the Mystic Seaport and the Mystic Aquarium & Institute for Exploration. Mystic's beautiful downtown is home to dozen of quaint shops and restaurants, and hosts festivals and events year-round."

Taken by postcard printer Ellery Twining for the Mystic Army-Navy Store, this image shows a view from one of the dock posts along the boardwalks that line the sides of the Mystic River Bascule Bridge. The docks are a popular local hangout spot for both young lovers in Mystic and the boats that come upriver from the sound to dock and fish or spend time in town. (Courtesy of Ellery Twining.)

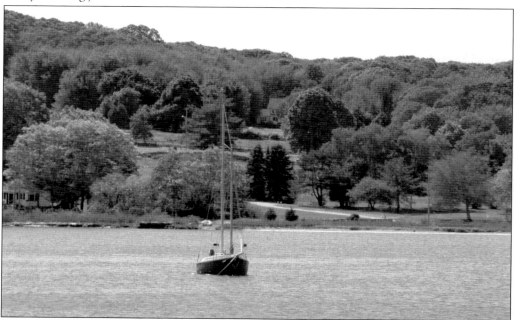

Although the identity of this boat is unknown (or it would have been included two chapters ago!), the vessel shows one of the great pastimes of the Mystic faithful and, indeed, much of New England: sailing. Much of the sailing in the area is done from the months of March to October, when weather is most favorable. (Courtesy of Ellery Twining.)

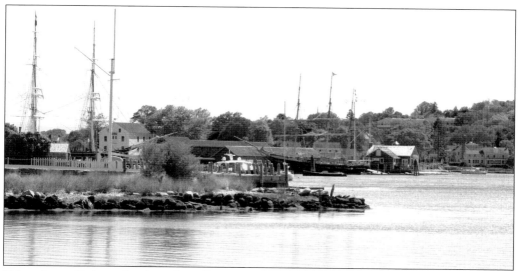

Taken from a little up the river, this Ellery Twining card shows several of the important museum ships, including the *Joseph Conrad* and the *Charles W. Morgan*, docked at Mystic Seaport on a bright spring day. Spring is one of the best times to visit the Mystic coast, as the warm weather and fresh Atlantic breezes make the area comfortable to both local and visitor alike. (Courtesy of Ellery Twining.)

As one of the top pleasure piers on the Atlantic Seaboard, the Mystic pier sees a lot of foot traffic —and boat traffic. Although piers like this have served everything from museum ships to *La Amistad* and the *USS Constitution*, they have seen their fair share of revitalization over the last several decades, as has most of Mystic. (Courtesy of Ellery Twining.)

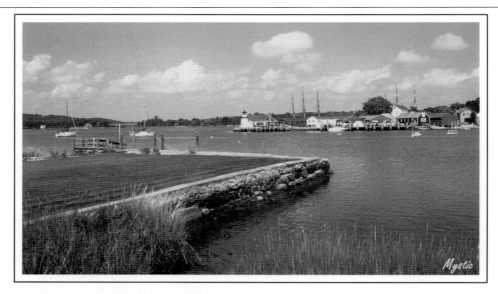

Connecticut Shoreline

This modern card shows a grass-covered pier across from Mystic Harbor. In the distance, one can see the schooner *Brilliant*, as well as the Mystic Lighthouse. Although Connecticut, like most New England states, suffered from some grade of coastline erosion during the rise of industry in the United States, the Tidal Wetland Act of 1969 and the Coastal Management Act of 1980 led to the restoration of several coastal areas like the ones seen here. What remains is an area that can be enjoyed by young and old alike.

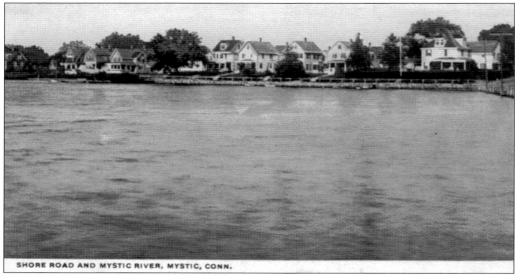

SHORE ROAD AND MYSTIC RIVER, MYSTIC, CONN.

Showing several homes along what appears to be Bay Street on the east side of the Mystic River, this 1907 artist's illustration depicts several of the quintessential charming homes that Mystic is known for. Today, local legend Alex Stackpole's parents live on Bay Street and generously host his high school and college colleagues from time to time. The front of the card reads, "Shore Road and Mystic River, Mystic, Conn."

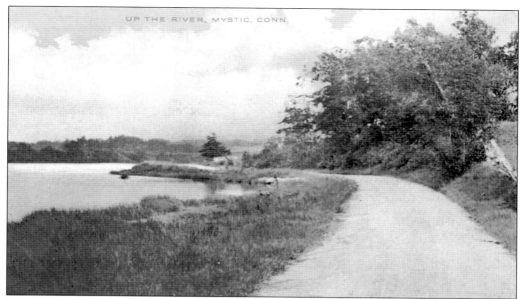

This artist's illustration from 1913 shows a long dirt road winding up the side of the Mystic River. Dirt roads largely prevailed in Mystic until the early 1900s, when federal acts began providing funding to pave them in response to the rise of the automobile. Such gorgeous views explain the appeal of the area to both locals and visitors, as nearly anyone can envision grabbing a fishing pole and settling in for a relaxing afternoon of idle fun.

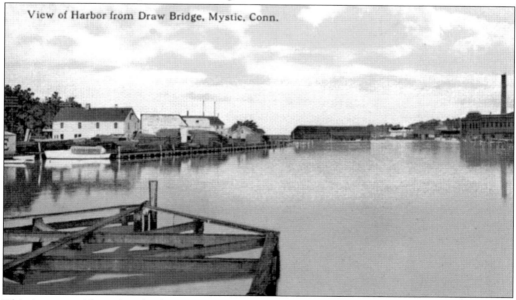

View of Harbor from Draw Bridge, Mystic, Conn.

This image, with a view looking south from the Mystic River Bridge, shows several historic landmarks—one of many shipyards on the left (east), Pistol Point in the distance, and the powerhouse on the right (west), which provided power for the trolleys. This artist's illustration was made before the Mystic River Bascule Bridge was installed in 1922, but after the trolley line was installed in 1904. The blurry advertisements on the sides of building and the calm waves harken back to an earlier time period in New England history.

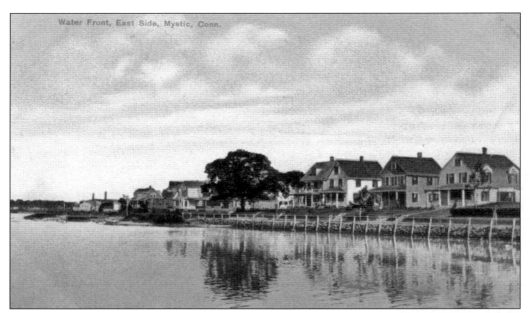

Taken from the shore near Holmes Street, this image shows the east bank (Stonington) of the Mystic River in 1908. The variety of charming New England homes that line Bay Street guide the perspective north to the smokestacks of the Rossie Velvet Mill, which was seized from its German national owners by the US government during World War I and now serves the Mystic Seaport as a museum and houses its archives.

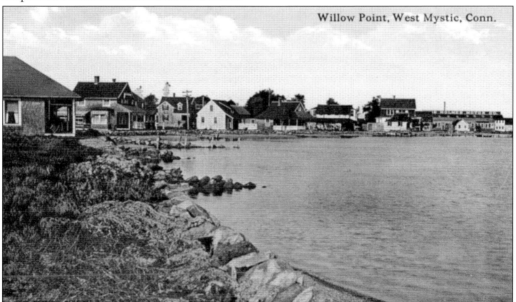

Although Willow Point once contained one of the first automobile dealerships in Mystic, it is better known as a residential neighborhood that laces the Mystic Harbor at the mouth of the Mystic River. This early-1900s artist's rendition shows a post-electrification West Mystic, with several styles of homes dotting the riverbank. Today, Willow Point has its own marina, which has served the construction and launching of ships for over a century.

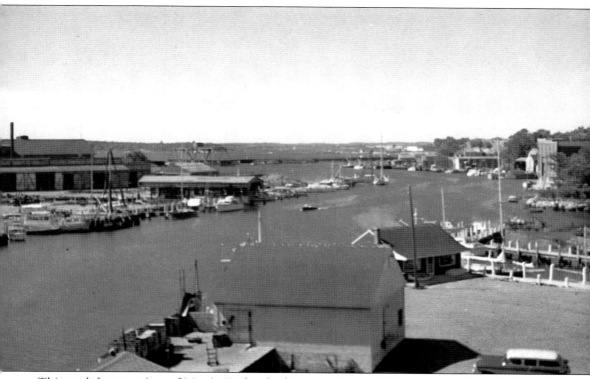

This card shows a view of Mystic Harbor looking south, possibly from the roof or window of a Main Street building around the 1950s. Much has changed in the nearly 400-year history of Mystic, but the harbor, and its beacon as the seafaring home of Mystic's sailors, has remained constant. Several ships, schooners, and sailboats are visible in this view.

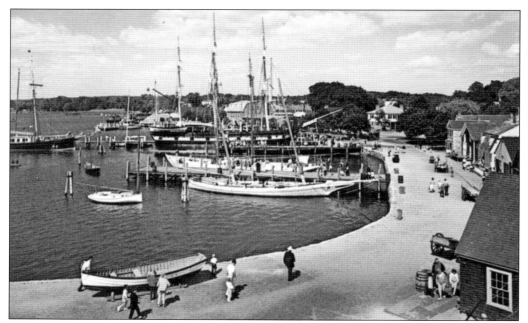

This aerial image, taken in 1966, shows what Mystic is all about—maritime heritage. Visible are not only the bulwarks *Charles W. Morgan* and *Joseph Conrad* but also several smaller vessels, both commercial and leisure. Several families are shown to be enjoying shopping on what appears to be a warm summer day, and children scurry about, no doubt enjoying all the unique aspects of the Mystic Seaport.

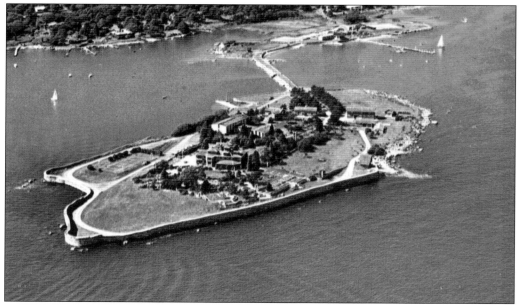

If people follows Yacht Club Road out of Mason's Island, they are taken to Enders Island, home to the Catholic St. Edmund's Retreat. This gorgeous stone edifice, shown from an aerial view, is home to both religious and personal ceremonies and is readily available to the Mystic public. Mass is celebrated almost daily in the Chapel of the Lady of the Assumption.

Four

LODESTARS AND LANDMARKS
SIGHTS AND SYMBOLS OF
MYSTIC HERITAGE

Every hometown in America has them—the restaurants, houses of worship, statues, streets, signs, and beloved attractions that make an area unique to all, but mostly those who call it home. And while Mystic has its fair share, what makes it truly unique is the nod that it all pays to a life that is of a different flavor than in any other part of the world.

Everyone—from the Mystic Seaport historians, who chronicle the bygone era of New England's maritime glory; to the fine artisans in the Olde Mistick Village; to the musicians who play on the street and in the restaurants; to the fishermen who fish alongside the Mystic River Bascule Bridge; and even to the ambitious entrepreneurs maintaining the pinnacle of fine seaside dining downtown—finds common ground here. Everyone has dined on East and West Main Street; everyone has fond of the creatures at the Mystic Aquarium; almost all know someone who is buried in Elm Grove Cemetery; and everyone has cruised through the rotunda around the Soldiers' Monument.

But these landmarks hold a special interest to those who visit Mystic as well. Although the area has more recently incorporated familiar national hotels, and even regional restaurants, there are also a plethora of locally owned establishments, each with its own character that contributes to the atmosphere that is Mystic. Historic inns dot the coastal town, catering to everyone from locals on staycations, to wayward local history buffs, to sailors or tourists on vacation—all looking for a good time.

Mystic is also a delight to those who are interested in the great transportation industry that helped New England grow into America's commercial and cultural juggernaut. Everything from the historical Groton and Stonington Street Railway to express Amtrak trains have found their way through the years to Mystic, and several of the area's historic businessmen have invested in transportation projects varying from the bridge at Mystic River to some of the earliest automobile companies. The following images capture many of the lodestars and landmarks that make a Mystic life truly unique.

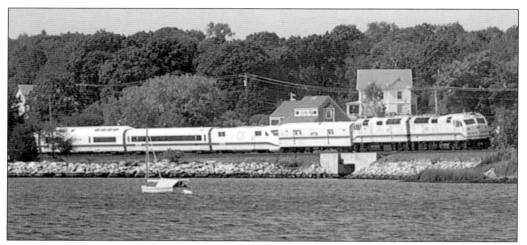

This card shows the famous Amtrak ICE Train steaming up the shore of the Mystic River. Taken on Tuesday, September 4, 1993, this view shows the Amtrak Model F69 locomotives 450 and 451 leading the train on what was a pilot drive for both the US Department of Transportation and the German ICE (InterCity Express) project. Although Amtrak still runs a route through Mystic that terminates in Boston, these cars are no longer a part of it. In 1999, they were both retired and now rest, stripped of valuable parts, in a National Railway Equipment rail yard.

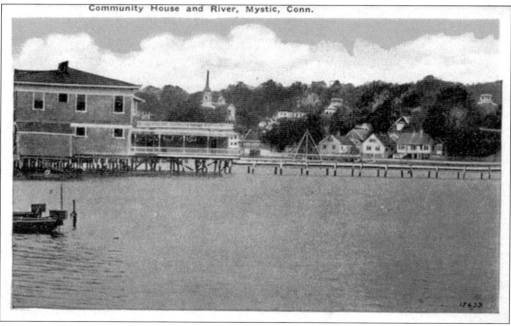

Community House and River, Mystic, Conn.

The eastward view in this 1920s postcard of the Mystic Club on Holmes Street, labeled here as the Community House, was taken from the river or a neighboring pier on the west bank. The club was originally organized in 1911 as the Mystic Cosmopolitan Club and boasted a full kitchen and even billiard rooms and a bowling alley. Boats and other equipment could be rented as well. Sadly, it was closed in the 1950s due to disinterest. In the background, on the land, the Union Baptist Church steeple can be seen.

While the history of St. Patrick Catholic Church and the Mystic Soldiers' Monument are detailed later in this volume, the history of the Congregational church (the white church in the center) is just as long. The church was organized in 1852, and the mission itself was completed in 1860. The church started with 42 members and, according to the church website, has "continued to grow." The parish hall, administration buildings, and the church's library were all added in the 1970s, and in 2002, the church celebrated its 150th year.

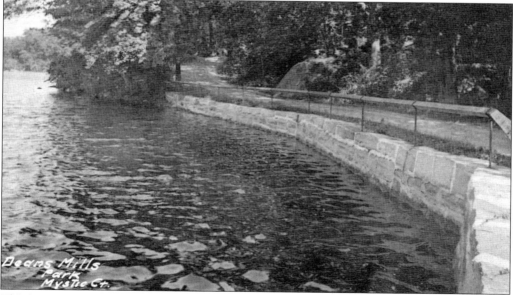

This is a 1910 image of the Deans Mill Park, which closed in 1922 to protect the reservoir. The Avalonia Land Conservancy took stewardship of the nearby forested areas in 1993 and opened trails for hiking that snake by the former park area, the views of which the conservancy describes as "mature, mixed hardwood forest with some intermittent wetlands." Some easy trails begin on Maritime Drive and at the Denison Pequotsepos Nature Center, with parking at both.

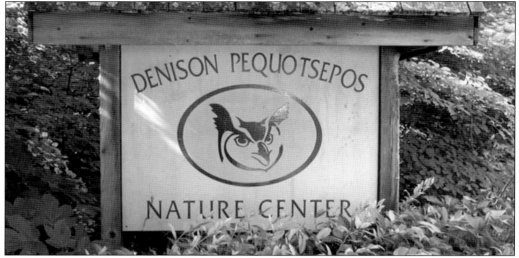

The crown jewel of the local conservation movement is Denison Pequotsepos Nature Center (DPNC), which was opened in 1946. The property holds over 10 miles of trails, the DPNC Nature Store, and a natural history museum that tells of the rich educational, historical, and ecological treasures on the property. Despite its seafaring and commercial heritage, Mystic is very much a part of the agricultural heart of the area that is on full display here.

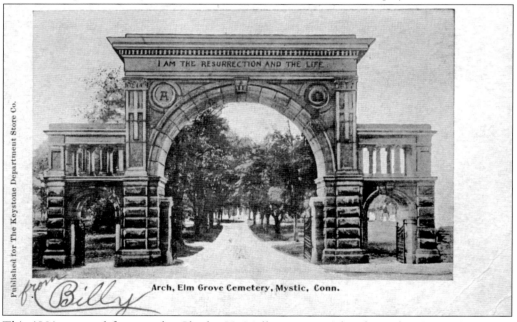

This 1901 postcard features the Charles H. Mallory memorial arch at Elm Grove Cemetery, which was built using granite from Westerly, Rhode Island, quarries. It is one of the most highly visible landmarks in Mystic and cannot be missed when driving by on Greenmanville Avenue. Local photographer and historian Taylor Harnish's grandfather and World War II veteran Edward M. Harnish and his wife, Madeline, are buried here. The Greenman Memorial Chapel inside was built in 1911 using Greek marble and at one point hosted a wedding. (Courtesy of Debbie Hindman.)

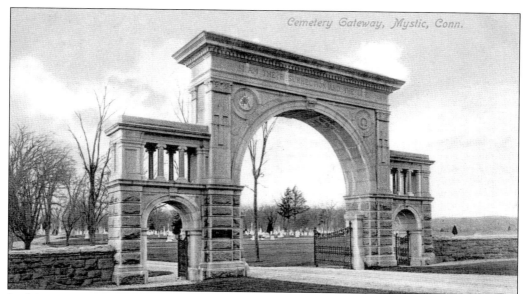

In this 1909 postcard, above the alpha and omega symbols on the main archway, the words "I am the resurrection and the life" are chiseled into the Charles H. Mallory granite memorial arch, erected in the 1890s by his widow and children. It looms 32 feet high, is 6 feet thick, and measures 54 feet from end to end. The cemetery was established in 1853 and is still in use, with the historic Greenman Memorial Chapel receiving renovations in 2008. Mystic's most famous families, including the Cottrells, Denisons, Greenmans, Hoxies, Mallorys, Schofields, and Spicers, are buried here.

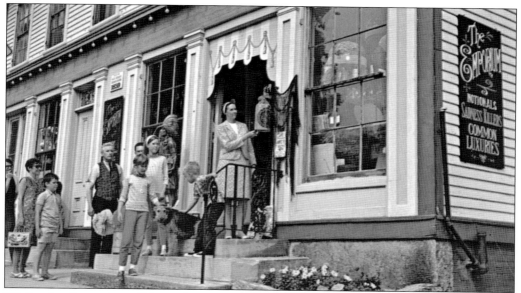

While the Emporium did not become popular right away, its connection to the Mystic community is rich. Mystic postcard manufacturer Ellery Twining, many of whose postcards are featured in this book, once worked there and still owns a large part of the postcards they sold there before it closed in 2013. Two young boys, named Billy and Willy, were said to haunt the building at night in their coal–stained clothes, although a 2011 investigation was inconclusive.

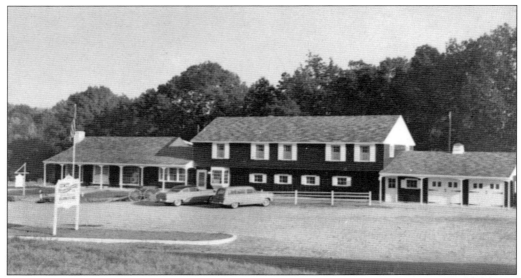

Published by the Cub Imprint of True Color Reproduction, this postcard shows the former Hewitt Woodcrafters on Route 95 in Mystic. The back of the card reads, "Hewitt Woodcrafters, Inc. Early American House. Antique Reproductions, Custom built furniture, repairing and refinishing. Showroom and shop, Route 95, Old Mystic, Conn." The Early American House offered the rare opportunity to see beautiful reproductions of pine, cherry, and maple furniture in an authentic setting. It closed in 1993, after 38 years in business.

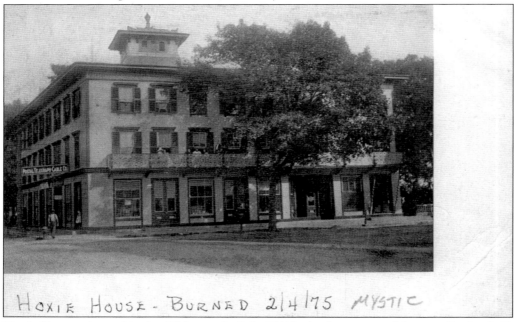

Hoxie House, pictured in the 1890s, was built in 1861 by businessman and investor Benjamin F. Hoxie after the U.S. Hotel burned down in 1858 in the same location, 20 East Main Street. The second and third stories had guest rooms, and the first floor had shops like the Postal Telegraph Cable Co. In 1924, it was renamed Hotel Mystic and eventually became part of the Whaler's Inn, which still operates. It burned down in 1975 and has been rebuilt twice since then.

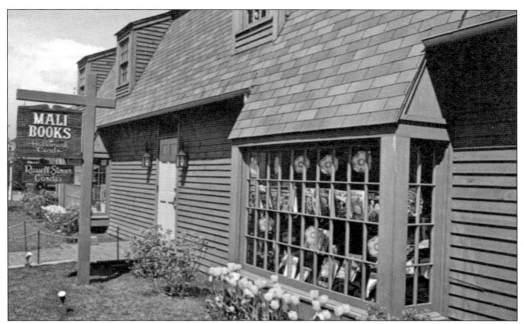

It is a sunny day in the 1950s at the Olde Mistick Village, a quaint replica of the 1720s Mystic seaside town (located directly off exit 90 from I-95). Pictured here above a flourish of tulips is the bay window of Mali Books, a former shop and purveyor of the popular Russell Stover confections and the classic cards of Hallmark. Today, Connecticut's own chocolatier, Munson's Chocolates, occupies the same shop space.

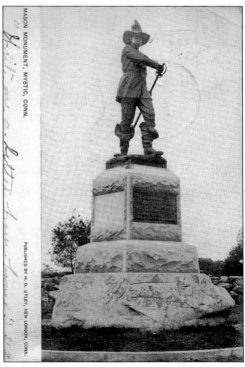

This 1908 postcard features the Mason Monument, honoring English settler John Mason, erected in 1889 near the sacred site of the former home of the Mashantucket (Western) Pequot Tribal Nation (MPTN) on the west side of the Mystic River, which he attacked 1637, killing between 400 and 700. The Pequots were "the first native people to survive [an attempted] genocidal massacre at the hands of the European immigrants," according to the MPTN website. The monument was relocated to Windsor in 1992. The MPTN now operates the world-renowned Foxwoods Resort Casino in Mashantucket (on the outskirts of Ledyard). (Courtesy of Groton Public Library.)

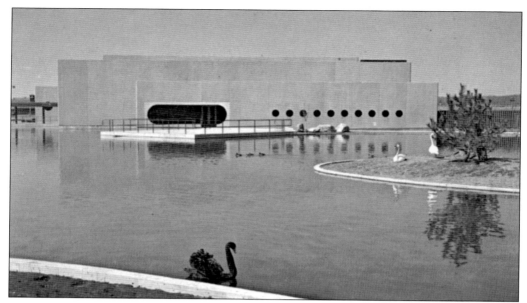

Pictured here is a view from the outside of the Mystic Aquarium (off exit 90 from I-95) in the 1970s. The aquarium was founded in 1973 as a research facility and public exhibit by Kevin Smith, an Ohio industrialist and chemist interested in marine biology. It has since been renovated and is home to beluga whales, stingrays, seals, penguins, and others. The aquarium hosts countless visitors every year, and even has a sea animal rehabilitation program.

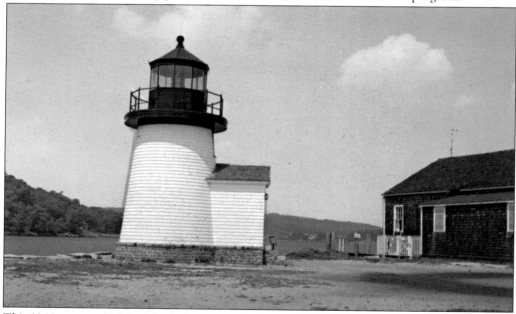

This 1960s postcard of the Mystic Seaport Light, located at the outermost peninsula of the Mystic Seaport Museum and seaport village, is a replica of the famous Brant Point Light in Nantucket, Massachusetts. It was built with funds donated by Dorothy and John P. Blair. While it is not used functionally, it does contain an original, working fourth-order Fresnel lens (provided by the Coast Guard), which allows lighthouses to create a strong, central beam of light.

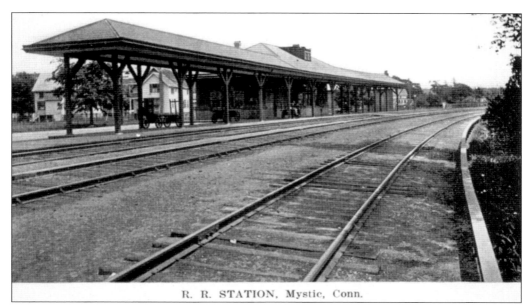

R. R. STATION, Mystic, Conn.

Baggage carts sit beneath the gabled canopy at the 1910 railroad station at 2 Roosevelt Avenue. The stop was created with the railroad in 1858, after which a station was added. It was replaced in 1905 by the one seen here, which the American Flyer toy company used as a model for 50-plus years—and the Mystic Chamber of Commerce office still has one on display. It was renovated in 1977, then from 2001 to 2015 was operated as a tourist center. In 2016, it became Mystic Depot Roasters, a delicious coffee shop that still has active Amtrak service.

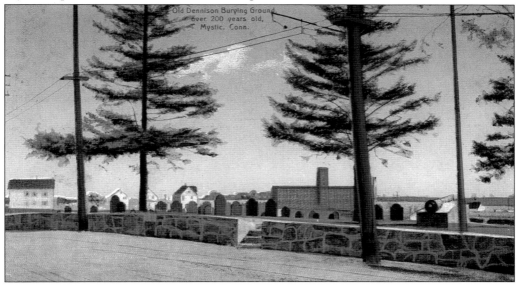

This is an early-1900s postcard of the Denison Burying Ground, which is located on Williams Avenue at the mouth of the Pequotsepos River. Denison Civil War and Revolutionary War veterans are buried in this cemetery, which was founded by the descendants of Capt. George Denison, who lived in Mystic from 1654 until his death in 1694. He built Denison Mansion, which was replaced in the early 1700s by his grandson with Pequotsepos Manor, which still exists at 120 Pequotsepos Road. Sondonia Mill is pictured in the distance.

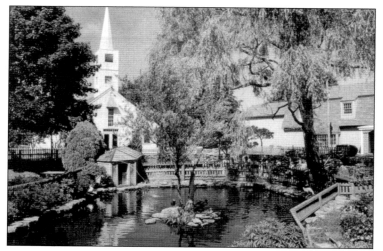

This 1990s postcard's summertime view of the duck pond in the Olde Mistick Village offers a picturesque look at the authentic St. Matthias Anglican Church located in the village at 27 Coogan Boulevard, Building 5, which was founded in 1978 and still offers services to this day. Church members are active participants in the Mystic holiday festivities each year.

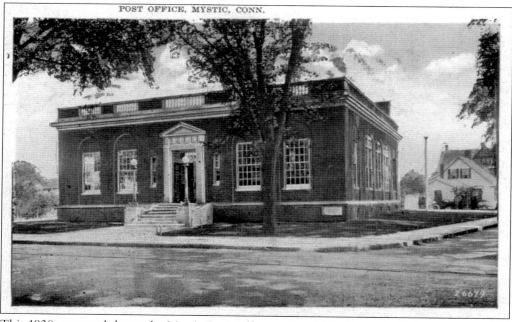

POST OFFICE, MYSTIC, CONN.

This 1930s postcard shows the Mystic Post Office on East Main Street, built in 1925 to replace the 1890 post office, which was more of a system running in numerous Main Street locations. The 1890 post office incorporated Mystic Bridge (east side) and Mystic River (west side) into one town. They had been called, respectively, Mystic Bridge (since 1835, with the advent of the bridge), and Portersville (from 1819 to 1850, named for the "Porter's Rocks" on the western shore of the Mystic River, where English and "River Indian" forces camped prior to attacking the Pequots in the Battle of Mistick Fort in 1637). Postal services in the two towns were consolidated just six years prior to this photograph being taken.

This 1906 postcard of the Union Baptist Church, which sits atop the hill on West Main Street to his day, was sent with this message scrawled on the bottom edge: "Waiting at the church." These days, the writer would probably wait for quite some time, but before 1925, the postal service operated via a system of relays between multiple locations on the main streets, so mail moved, and was retrieved more frequently throughout Mystic than people are used to today.

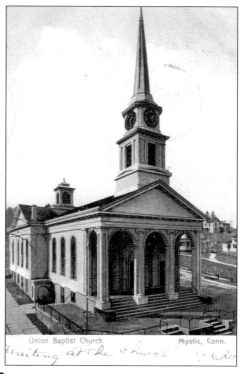

Union Baptist Church. Mystic, Conn.

Waiting at the Church

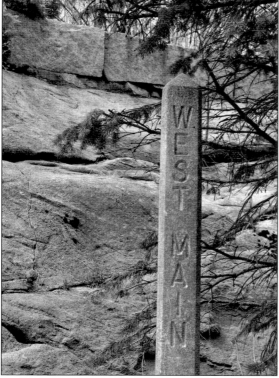

Pictured is a close-up of a stone obelisk-shaped street sign in Mystic. According to neighboring Ledyard locals like Steve Masalin, street signs like this are rumored to have evolved from granite horse hitches (that likely doubled as boundary markers). They were common in formerly rural coastal towns, and some that are currently painted white with black lettering can be seen in neighboring towns like Ledyard (formerly Quakertown) and Groton. Unfortunately, these relics of local history are slowly disappearing, being replaced by modern reflective street signs, which are much easier to see. (Courtesy of Ellery Twining.)

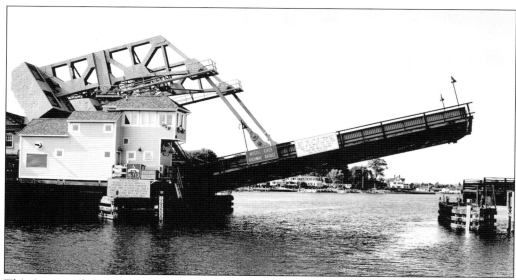

This image of the Mystic River Bascule Bridge from the early 2000s shows it opening to allow boats passage. It is arguably the most familiar sight in the town, and locals and tourists alike love to watch it from the benches that line the boardwalk along the east side of the river. Mystic River Park sits behind the benches and the boardwalk on Cottrell Street, near where this photograph was taken.

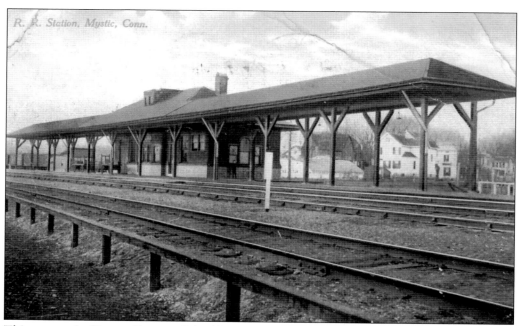

This postcard offers a glimpse of the Train Depot. The original was built shortly after 1858 but was replaced by the one seen here in 1905 at 2 Roosevelt Avenue. It has been renovated, rebuilt, and repurposed several times by organizations like the Mystic Depot Inc. (made up of local residents) and the chamber of commerce, but even when the building itself was closed, train service still continues there today. All aboard!

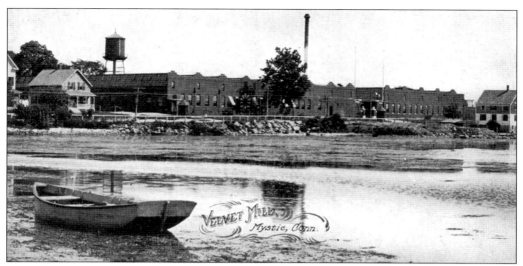

The Rossie Velvet Mill was built in 1898 on Greenmanville Avenue and Velvet Lane by the Mystic Industrial Company to attract foreign business interests like the German Rossie family-owned velvet company, which produced high-end velvet materials. Over 200 workers (mostly German) lived nearby, and even founded Frohsinn Hall as a clubhouse, which still stands on the same road. Because the Rossie family were German nationals, the mill was seized by the US government during World War I. The building is now the home of the Mystic Seaport Museum.

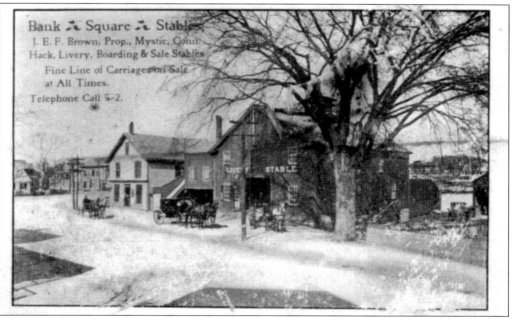

A scene from Bank Square in Mystic in the late 1800s shows Sheriff Jim E.F. Brown's livery stable, located to the right of Ms. Agnes Park's Variety Shop, which was built by I.D. Miner in 1897 and purchased by Park in 1900, making her one of the chief businesswomen in the area. The caption reads, "Hack, Livery, Boarding & Sale Stables Fine Line of Carriages on Sale at All Times. Telephone Call 5-2."

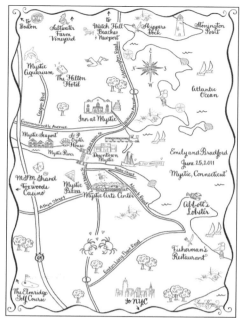

Calligrapher Laura Hooper's custom-made save-the-date postcard for writers Emily McLaughlin and Bradford Kammin's 2011 Mystic wedding at the Mystic Art Gallery and Haley Mansion (popular wedding locales) is seen here, highlighting some of the area's most beloved date and vacation spots. Their photographer, Robert Norman, asked on his blog, "What are [tourists] going to DO with those pictures of a [bride] they do not even know??" Robert may not have known what tourists would do with Emily and Bradford's wedding pictures, but their stationery wound up nationally published!

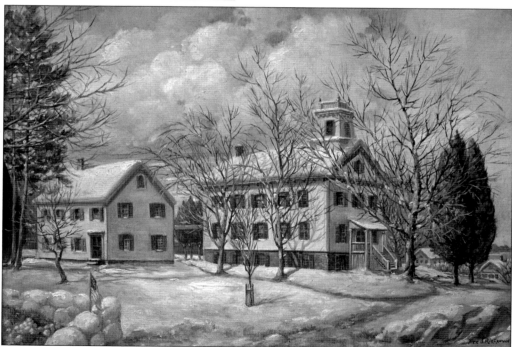

A c. 1906 chilly winter view shows the private educational institution called the Mystic Academy. Education in the mostly Protestant Mystic community of New England had always been a priority, with goals to teach both boys and girls, Native Americans, and African Americans the basics of literacy. The building with the belfry opened above Pearl Street in 1852 and the smaller one behind it in 1879. Both were replaced in 1911 with a three-story brick building that now operates as an assisted living community.

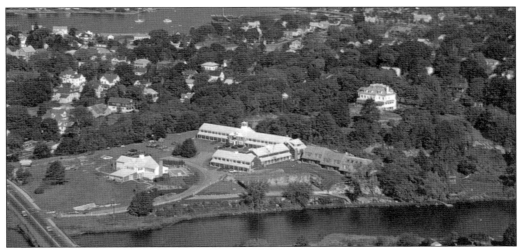

This 1982 aerial view shows the J-shaped former Mystic Motor Inn, a popular vacation destination formerly located on Williams Avenue along the Pequotsepos River. The Flood Tide Restaurant, whose motto was "the crest of fine New England dining," was located in the building to the left of the inn. They have since been replaced by the Harbor House Restaurant and the Inn at Mystic, which occupies both the original inn and the Colonial Revival Haley Mansion, built in 1904 to the right of the inn.

"A Slice of Heaven" is what customers will get at the world-famous Mystic Pizza at 56 West Main Street. Opened in 1973 by the Zelepos family, it was catapulted to stardom with the 1988 major motion picture that Siskel and Ebert gave two thumbs up—*Mystic Pizza*, starring a young Julia Roberts. Today, the restaurant has a frozen pizza line the owners claim "doesn't taste like a box" and a second location, Mystic Pizza II, in North Stonington.

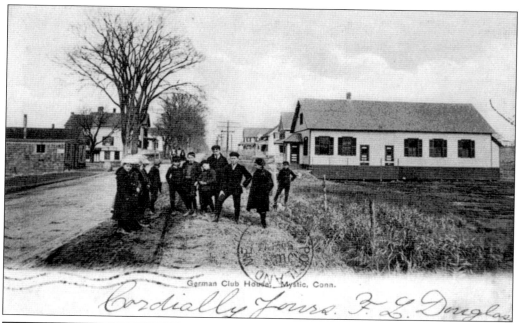

German Club House, Mystic, Conn.

Cordially Yours. F. L. Douglas

A group of Rossie Velvet Mill workers gathers in front of the newly completed Frohsinn Hall (first white house on the right), built by the social society Frohsinn at 54 Greenmanville Avenue in 1906. German weavers employed by the mill formed the society and funded construction. "The German Club," as it is affectionately called by locals, still exists in this location and hosts events and concerts with local and Connecticut-turned-international bands like the Hempsteadys, Dead City Riot, Can Kickers, and Bragging Rights.

Here is a delicious look at some of the most popular destinations in Mystic, all baked into one delicious Mystic Pizza postcard produced by the famous Mystic Pizza restaurant on West Main Street, which sells pizza by the slice or by the pie in its historic two-story establishment, opened in the 1970s. Each morsel of history listed here is featured in the pages of this very postcard book.

Five

Mystic Realms of Time
Mystic, Then and Now

While some names, places, and landmarks tend to come and go, whether through repurpose, relocation, or destruction, there are several mainstays of Mystic that seem like they will forever be a part of the fabric of the town, and their familiar positions in locals' lives a constant. These landmarks have weathered a variety of destructive forces, including hurricanes and even the occasional bout of bad engineering, yet they manage to remain as beacons and beloved sights to those who call Mystic home, their fondness for each landmark passed down from generation to generation as though cherished heirlooms.

The local parishes and their churches have also been firmly entrenched in the lives of generations of locals since Mystic's inception, and the fact that these entities, all based on the generosity of their parishioners and congregations, manage to rise from the ashes every time disaster strikes is a testament to the reverence of religious life to the Mystic faithful. While the houses of worship have been rocked by everything from scandal to storms, they still are, and will forever be, viewed as vital sanctuaries and moral compasses in the lives of those who attend services there.

Even public services, like the library, and private homes, like the estate of Charles Q. Eldredge, still exist as unofficial monuments commemorating over 300 years of life and prosperity in Mystic. And much like the magnificent Leete's Island granite that features in the Mystic & Noank Library, or the New London lumber that Charles Eldredge used to build his home and museum on the Mystic River, these sturdy examples tell the story of some of Mystic's most time-tested mementos.

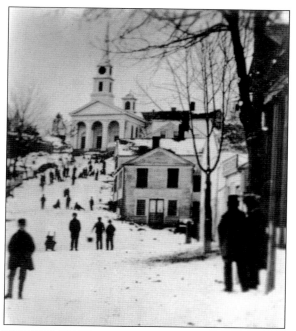

This chilly c. 1900 view shows West Main Street's Baptist Hill, so named for the iconic Union Baptist Church at its crest. Built in 1765 for the Second Baptist Church in Groton, the structure was pulled by oxen in the early 1860s to its perch seen here and joined with the existing Third Baptist Church building (built in 1831) to become Union Baptist Church. Sunday bells called people to worship, and locals relied on the highly visible clock to tell time.

Newly paved roads grace Baptist Hill on West Main Street in this late-1920s postcard. Until 1923, West Main Street terminated at Union Baptist Church. In 1924, however, the road received labor-intensive improvements, with boulders being blasted away from its sides to make room for a concrete paved street, which took a week to harden enough to be driven on. The paving made traversing the hill via automobile (an increasingly popular mode of transportation in that era) much easier. In 1938, shortly after this painting was made, the church's green steeple was toppled by a hurricane.

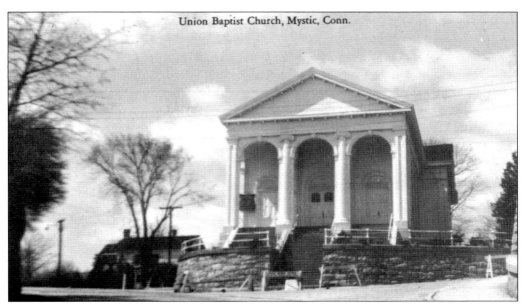

Union Baptist Church, Mystic, Conn.

This postcard photograph of a steeple-less Union Baptist Church was taken after the devastating hurricane of 1938, which made landfall in New England in late September of that year. It is estimated to have caused $306 million in damages (nearly $5 billion in today's dollars) and killed well over 600 people. The steeple and clock tower of the church were swept off, spoiling the picturesque view of an iconic town landmark beloved for over 70 years.

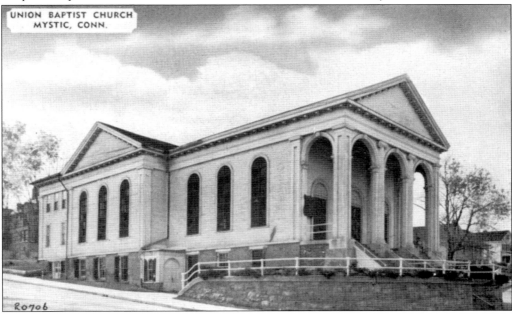

UNION BAPTIST CHURCH
MYSTIC, CONN.

This 1940s or 1950s side view of the Union Baptist Church depicts the new vision of normal that capped the top of the well-traveled West Main Street for 31 years after the 1938 hurricane, which devastated New England at the tail end of the Great Depression. The T shape of the church can be seen; it was formed in 1865 when the Second Baptist Church structure (front) was pulled to conjoin the existing Third Baptist Church building (rear).

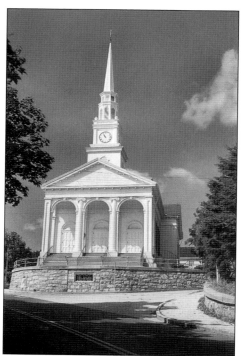

Fully restored in 1969 to its former glory, the Union Baptist Church can be seen in this late-1960s or 1970s postcard. The new white steeple, bell tower, and clock were built over 30 years after the originals had been demolished in the 1938 hurricane. Renovations included closing off the stairs in front that reached the road (as cars at this time were faster than ever before) with a stone wall and an announcement sign. Regular services are still held to this day.

A 1910 interior view of St. Patrick Roman Catholic Church is seen here. Originally built by the Methodists, the church was purchased and renovated by Fr. Patrick Sherry in 1870. Bishop Francis MacFarland, the "Civil War Bishop," dedicated it during a 2,000-person ceremony to the 50 or so local Irish Catholics (out of only 450 in Connecticut, attracted mostly by the shipbuilding industry) who would worship with Father Sherry. In December 1871, Fr. Patrick Lawler became the priest after Father Sherry's death.

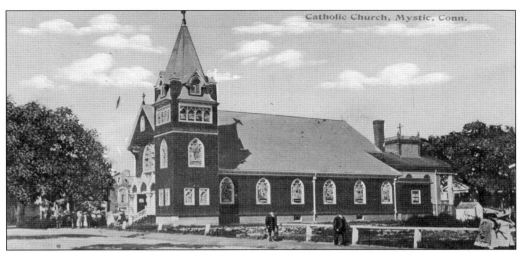

This 1912 portrait of the Mystic St. Patrick Roman Catholic Church shows the distinctly ornate architecture and colorful stained-glass windows on the side of the house of worship 42 years after being built. It would remain intact about the same amount of time after this before being altered significantly in the 1960s. It would come to weather the disastrous hurricane of 1938, and would also bear witness to the nation's first Catholic president, John F. Kennedy.

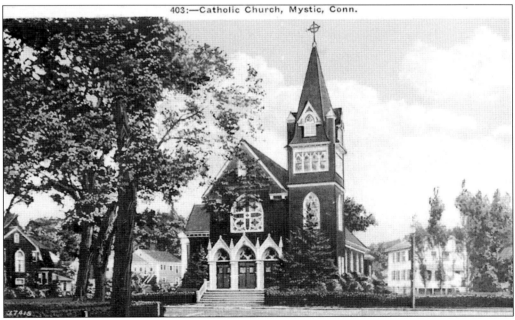

403:—Catholic Church, Mystic, Conn.

This summery 1930s postcard depicts the picturesque St. Patrick Roman Catholic Church on East Main Street. By this point in Connecticut, the Catholic population had boomed from a miniscule Irish Catholic minority of 450 in 1870 and grew through a period of anti-Catholic sentiment to well over 375,000 in the state, including German, Italian, French Canadian, and Polish immigrants, as well as converts. Its brown exterior and colorful stained-glass windows contrasted with the two white clapboard Protestant churches downtown.

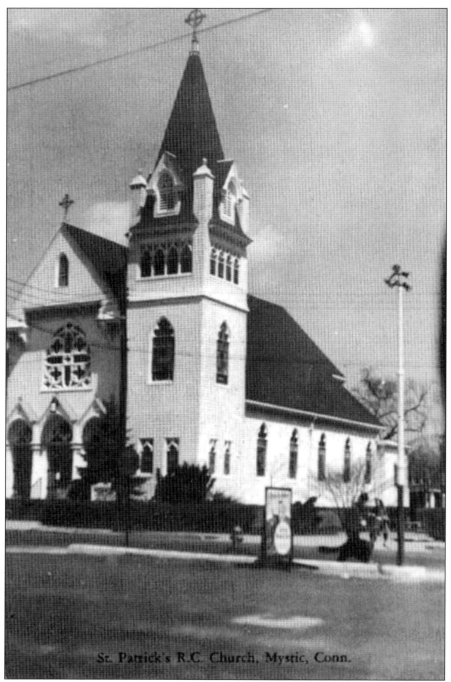

St. Patrick's R.C. Church, Mystic, Conn.

Newly renovated, the St. Patrick Church gleams on a balmy 1960s New England day. Improvements to the church since the 1960s include a white paint job and the installation of a roofed entrance porch beneath the Gothic archways. The archways have since been replaced with a porch, aluminum siding has been added, and a recent expansion added a one-story a parish hall. Regular masses are still held there today.

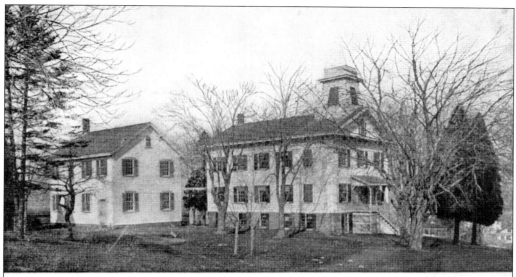

A 1906 photograph shows Mystic Academy, a select, prestigious private school organized and funded in 1850 by local merchants Charles H. Mallory, Capt. Nathan G. Fish, and Isaac Randall. The building with the belfry was constructed on a cliffside above Pearl Street in 1852 and served hundreds of pupils from as far as Spain, Panama, Cuba, and New Granada. In the late 1850s, the school became public, and the second building was erected in 1879 for lower grades.

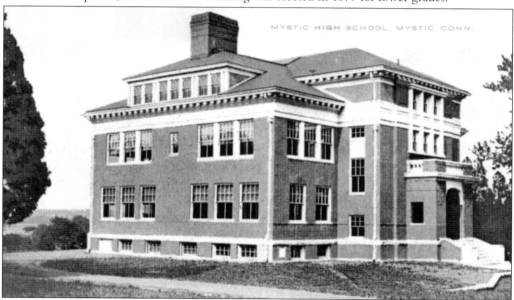

To compete with the new Broadway School that opened across the river, the two wooden buildings at Mystic Academy were razed in 1908 and replaced with this three-story brick building, which opened in 1911. It housed all grades, and the outhouses, which formerly earned local praise, were swapped for indoor plumbing and a rudimentary waste-disposal system that dumped directly into the Mystic River. In 2001, the building became the Academy Point at Mystic, a historically charming assisted living community.

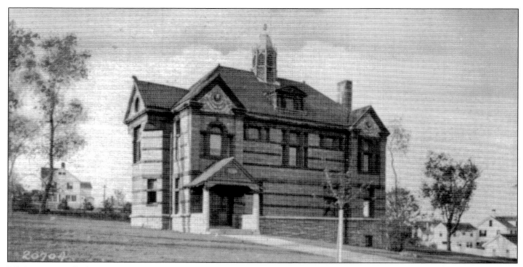

This turn-of-the-century postcard commemorates the Mystic & Noank Library, on the corner of Elm and West Main Streets. Business partners with Charles Mallory, Capt. Elihu Spicer had his architect supervise construction. Sadly, Captain Spicer died from a carriage fall in 1893, but his sister Sarah Dickinson ushered its completion. A beloved library cat, Emily, lived there from 1989 to 2006; she is buried on the well-manicured grounds and commemorated with a stone marker, and a scrapbook of Emily's life is available at the reference desk. Captain Spicer's mansion at 15 Elm Street was renovated in 2016 and is now a luxury bed-and-breakfast.

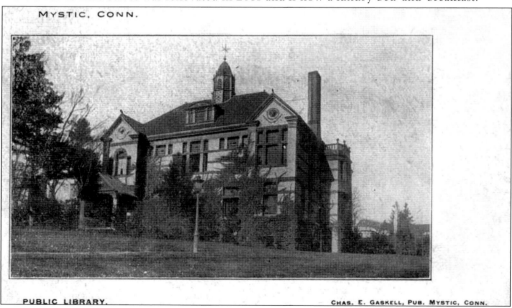

MYSTIC, CONN.

PUBLIC LIBRARY. CHAS. E. GASKELL, PUB. MYSTIC, CONN.

Pictured just four years after its opening, the Mystic & Noank Library is shown cloaked in ivy that Captain Spicer's sister Sarah Dickinson personally brought from England. Other imports include floor tiles from Italy and Numidian marble staircases. The 4,000 books that Captain Spicer originally willed are housed under the oak cathedral ceiling of the second story, accompanied by an inscription above the fireplace that reads, "Elihu Spicer gave this library to the people. Large was his bounty and his soul sincere."

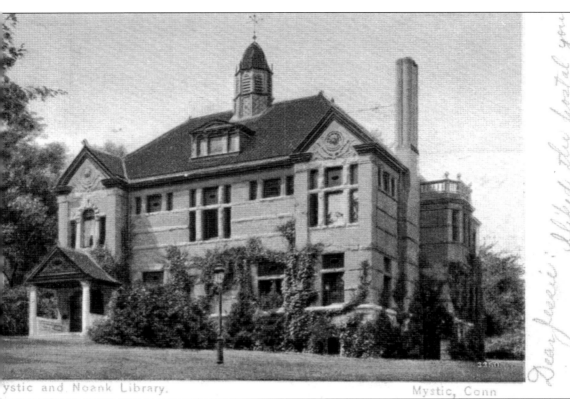

An artist's depiction of the library displays its main entrance and artistic architectural exterior elements. High above the main entrance porch on the left side of the building, a sculpted frieze depicts the Roman goddess Minerva, a tribute to literature. Mirrored on the right side of the building in the same spot is a sculpted frieze representing the Roman god Apollo, a tribute to the arts. Many American materials throughout the country were used in its construction, including marble from Vermont and Tennessee and Leete's Island (Connecticut) granite.

The home of local eccentric and curiosity museum owner Charles Q. Eldredge, called Riverview, is seen here after its construction in 1890. Eldredge grew up in Mystic, then worked in Wisconsin, Mississippi, and New York lumber businesses before returning permanently in 1893. He paid workers from his New York business to build it with 600 tons of lumber from New London's Bentley & Co., transported on what he called "the largest vessel that ever came to the headwaters of the Mystic River." (Courtesy of the New York Public Library.)

This 1910 postcard features the estate of Charles Q. Eldredge. Its 30-acre yard boasted a 125-foot observation tower with views of Block Island and Long Island, outdoor fireplaces and patio furniture, a yacht and rowboats that Eldredge himself built, and a regulation 65-foot bowling alley with shooting gallery adjoining. The hospitable Eldredge wrote, "I felt when I built 'Riverview' that it was largely for my friends, and their enjoyment was to me the greatest of my compensations."

Pictured is an illustration of the new Charles Q. Eldredge home purchased sometime after 1913 and previously a tenant house on the Eldredges' former property. Eldredge sold the original home following the suicide of his 18-year-old son in 1904, then traveled with his wife to the West Indies, including Haiti, as well as Panama. Eldredge returned to Old Mystic around 1913 and in 1917 opened a "museum of curios," furnished with relics from his journeys that drew thousands of visitors each year and renewed his local notoriety.

ADJOINING "RIVERVIEW COTTAGE" OLD MYSTIC, CONN.

Charles Q. Eldredge stands outside the museum built on his property in 1917. The sign on the side says "Private-Museum," and the caption reads, "The entire construction of this building, excavation, foundation, inside finish, tin work, roof, decorating and lettering were ALL personally performed by the owner, Chas. Q. Eldredge, in his seventy-second year. Something over 3000 Souvenirs and Curios are on Exhibition and to view them, his friends are ever welcome."

The entire construction of this building, excavation, foundation, inside finish, tin work, roof, decorating and lettering were ALL personally performed by the owner, Chas. Q. Eldredge, in his seventy-second year. Something over 3000 Souvenirs and Curios are on Exhibition, and to view them, his friends are ever welcome.

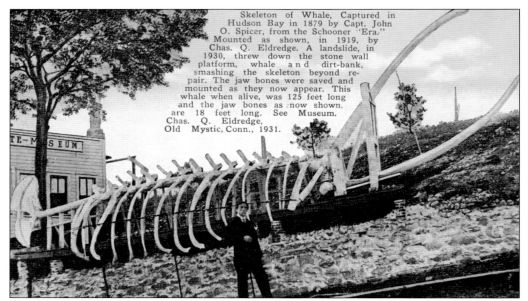

Skeleton of Whale, Captured in Hudson Bay in 1879 by Capt. John O. Spicer, from the Schooner "Era." Mounted as shown, in 1919, by Chas. Q. Eldredge. A landslide, in 1930, threw down the stone wall platform, whale and dirt-bank, smashing the skeleton beyond repair. The jaw bones were saved and mounted as they now appear. This whale when alive, was 125 feet long and the jaw bones as now shown, are 18 feet long. See Museum. Chas. Q. Eldredge, Old Mystic, Conn., 1931.

Charles Q. Eldredge stands in front of the skeleton of a whale that was captured in Hudson Bay by Capt. John O. Spicer, relative of philanthropist Capt. Elihu Spicer, builder of the Mystic & Noank Library. Other museum "curios" were cataloged and included a four-foot bronze cucumber, Harriet Beecher Stowe's purse, and Thomas Edison's first incandescent bulb. The museum (at left) was free of charge, and many patrons, after they visited, sent artifacts to Eldredge to include in the museum.

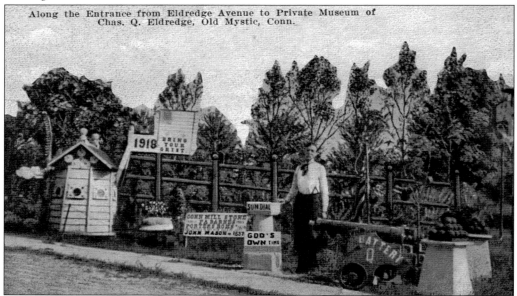

Along the Entrance from Eldredge Avenue to Private Museum of Chas. Q. Eldredge, Old Mystic, Conn.

The peculiar Charles Q. Eldredge stands next to advertisements in the 1920s for his widely popular oddity, the "museum of curios." Born without a middle name, Eldredge pulled a grade school prank to falsify one, but it was popularized so well among his peers that it became his legally documented name. Eldredge justified his local reputation as a funny and quirky personality with a childhood fall from an oxcart in his memoirs: "Some have said this fall affected my brain."

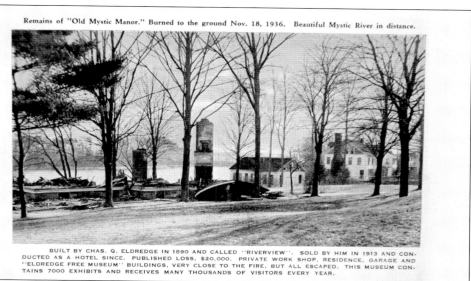

Remains of "Old Mystic Manor." Burned to the ground Nov. 18, 1936. Beautiful Mystic River in distance.

BUILT BY CHAS. Q. ELDREDGE IN 1890 AND CALLED "RIVERVIEW". SOLD BY HIM IN 1913 AND CON-
DUCTED AS A HOTEL SINCE. PUBLISHED LOSS, $20,000. PRIVATE WORK SHOP, RESIDENCE, GARAGE AND
"ELDREDGE FREE MUSEUM" BUILDINGS, VERY CLOSE TO THE FIRE, BUT ALL ESCAPED. THIS MUSEUM CON-
TAINS 7000 EXHIBITS AND RECEIVES MANY THOUSANDS OF VISITORS EVERY YEAR.

This 1930s postcard displays the remains of the original Eldredge residence, which had been sold in 1913 but was destroyed by a devastating fire in 1936. The home where the Eldredges lived, the workshop he built, and his museum of curios were unscathed. The eccentric but beloved Eldredge died the following year at age 92. The museum has been demolished and artifacts auctioned, but his homestead at 1130 River Road now operates as a five-bedroom rental property, still named Riverview Cottage.

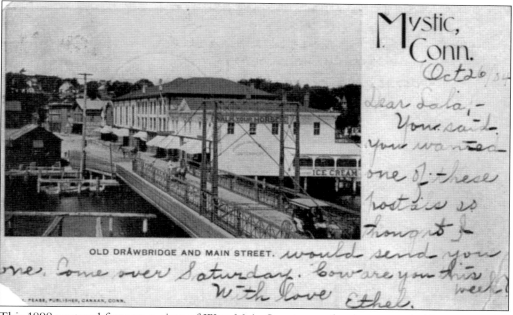

OLD DRAWBRIDGE AND MAIN STREET.

This 1898 postcard features a view of West Main Street over the downtown bridge connecting West Main Street with East Main Street. This iron turntable bridge was constructed in 1866 to replace the last wooden bridge (built in 1854), which ended toll requirements. Prior to that in 1835, the drawbridge became oxen-pulled to accommodate upriver ships. The first bridge was built in 1819 as a response to the advent of the shipyards crucial to the growth of the area.

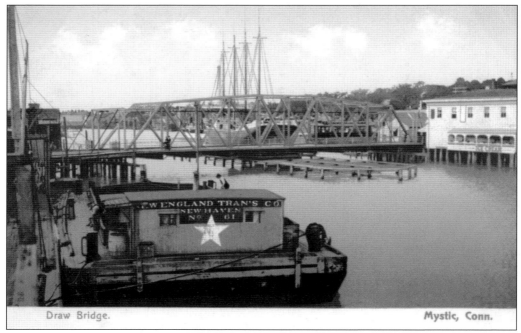

Draw Bridge. Mystic, Conn.

A tall ship awaits the opening of the steel through truss swing bridge in this postcard with a view from the north side of the Mystic River, dated 1906. The bridge opened in 1904 and was built by Burlin Construction Co. It was installed to accommodate heavier loads of traffic due to the opening of the new Groton and Stonington Street Railway, which operated in Mystic from 1904 to 1928 and one of whose trains is pictured crossing.

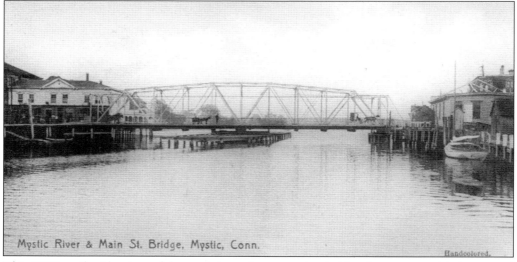

Mystic River & Main St. Bridge, Mystic, Conn. Handcolored.

This 1908 south-side view of the steel through truss swing bridge shows men with horses and carriages crossing the bridge. Trolley tracks spanned the length of the bridge, which was shared by trolleys, pedestrians, and carriages. The weight burdens frequently caused the mechanism on the swing bridge to inconveniently jam for hours while open, which was still better than its previous version built nearly 40 years prior, which the Historic American Engineering Record claims was of "questionable design from the perspective of scientific engineering."

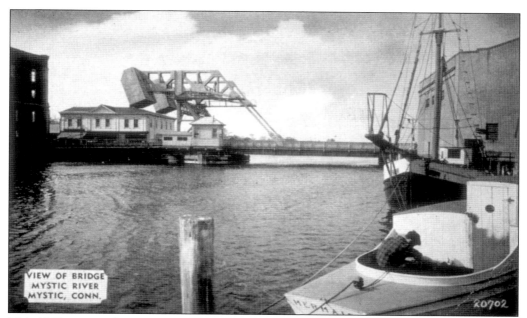

This 1920s postcard commemorates the July 19, 1922, opening of the legendary Mystic steel single-leaf bascule (French for "teeter" or "seesaw") bridge, designed and patented by Thomas Brown in 1918 as the innovative Brown Balance Beam Bascule, the first in America. The two large concrete blocks atop the bridge weigh 230 tons and act as counterweights to pull the bridge upwards. It was built in response to the importance of truck transportation of farmers' goods across the largely rurally invested state and cost $254,000 to construct.

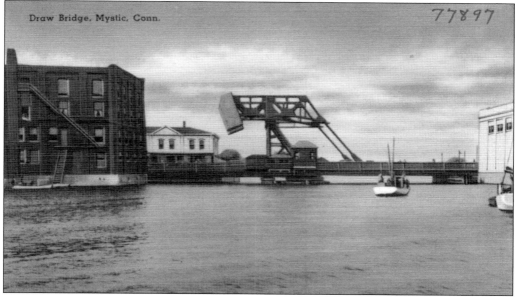

In the late 1930s, the two 230-ton concrete counterweights atop the bridge were encased in a steel-plate covering. The one-story, roadway-level operating house that flanked the bridge on the south side can also be seen here. The bridge came equipped with two 36-horsepower engines, and at the time, the bridge was mostly surrounded by shipyards and industrial businesses.

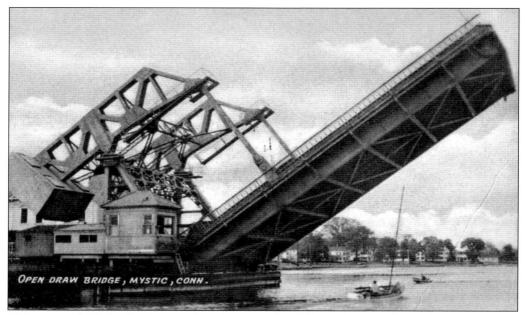

This postcard, likely dated somewhere between the 1930s and 1940s, shows the Mystic River Bascule Bridge opening to allow sailboats to pass beneath it. The bridge is opened thousands of times per year and has two main mechanisms of action—electric motors and the two 230-ton counterweight apparatuses seen atop the bridge—and includes a hydraulically operated brake. The design of the bridge is especially well-suited for this particular location, which is only four feet above mean high tide.

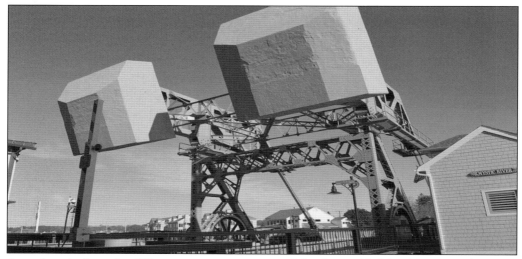

A modern look at the 230-ton concrete counterweights is provided in this postcard picture taken in the early 2000s, courtesy of Ellery Twining. The operating house seen at right, on the bridge's south side, was made to be two stories sometime before the 1950s. The bridge still exists and operates regularly today, and it recently was transformed from a bright yellow to a subdued gray.

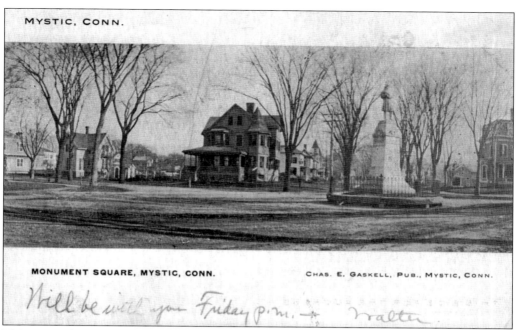

This turn-of-the-century postcard depicts the 47 East Main Street Soldiers' Monument, dedicated in 1883. Charles Conrads sculpted the $5,000 tribute to Civil War soldiers, and it was funded by Charles H. Mallory and the Williams Post No. 55, Grand Army of the Republic. Around 10,000 people attended the ceremony covered by the *Norwich Bulletin* and *New London Day*, the latter of which reported that the grandstand collapsed and the mistimed firing of the cannon salute "thoroughly honeycombed" marchers' faces "with burning powder, clothes were scorched, one leg severely bruised."

Trolley tracks can be seen below the Civil War Soldiers' Monument at the corner of East Main Street and Broadway Street in this early-1900s photographic postcard. The four-faceted granite base of the monument hoists an infantry soldier aloft, and the southwest face, seen here, commemorates the Battle of Antietam at top and is "dedicated to the brave sons of Mystic, who offered their lives for their country, in the War of the Rebellion 1861–1865" below.

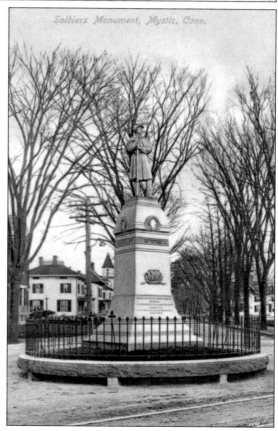

Soldiers Monument, Mystic, Conn.

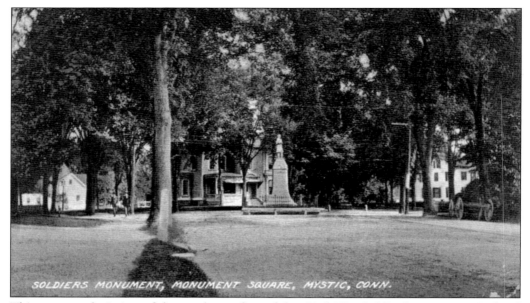

SOLDIERS MONUMENT, MONUMENT SQUARE, MYSTIC, CONN.

This summer depiction of the northwest face of the Civil War Soldiers' Monument is dated sometime in the early 1900s. Granite used to build the monument was supplied from the nearby Westerly, Rhode Island, quarry. The battle commemorated in the limbs of a sculpted wreath at the top of the northwest facet of the monument is Port Hudson. Several soldiers from Mystic who lost their lives in these battles are buried in the nearby Elm Grove Cemetery.

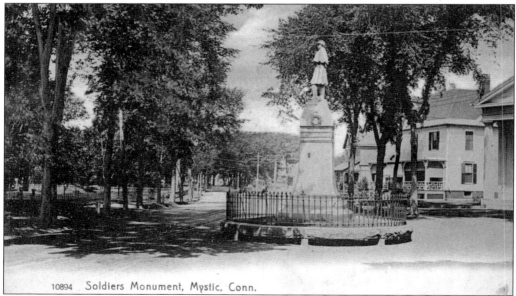

10894 Soldiers Monument, Mystic, Conn.

Power lines and trolley tracks lace the roadways in this view, dated sometime in the 1910s or 1920s, of the southeastern face of the Civil War Soldiers' Monument. The upper tier of the base commemorates the Battle of Drury's Bluff within the branches of a sculpted wreath identical to those on the other sides. The opposite, northeast face memorializes the Battle of Gettysburg. Today, the monument sits in the center of a traffic circle between Citizens Bank, CVS, Apple Rehab, and the Mystic Congregational Church.

Six

SEAS THE DAY
THE WAY OF MYSTIC LIFE

Mystic is a marvelous place to call home. Generations of families—from farmers, to merchants, to seamen, and even New England elite—have shaped its coastal culture. A variety of talents and contributions have given Mystic many modes of entertainment and industry. Specialty boutiques line West and East Main Streets, along with ice-cream parlors, confectioners, trinket and souvenir shops, bookstores, upscale jewelers, and even an Army-Navy store.

The seaside town also harbors several unique elements of New England history. From the Mashantucket Pequot Tribal Nation, who were the first to recognize the area's exceptional bounty as well as the first known to name and inhabit the area; to the African American slaves and Revolutionary War soldiers, and later, freedmen; to wealthy families who preserved their business empires through marriage or fraud; to the throngs of Irish shipbuilding immigrants, hardworking Italian railroad laborers, and Scottish marina operators, the tales told by the streets of Mystic are heavy with history. The area is so distinctive and exciting, in fact, that two major movie productions (the Julia Roberts starrer *Mystic Pizza* and the Steven Spielberg–directed *Amistad*) have found inspiration and foundation in Mystic.

Any local will note, however, that Mystic is its own exceptional little corner of Connecticut. It maintains its own chamber of commerce, and each annual festival—from the Sea Music Festival in mid-June to the Outdoor Arts Festival in August—carries Mystic's name. Mystic's denizens have managed to maintain a firm independence about their town that these descendants doubtlessly derive from their brave and industrious ancestors, who dared to sail the Atlantic to settle here. This inherent industriousness gave rise to a variety of people who, with next to nothing, created a dizzying variation in styles of homes, constructions, and trades.

This independence, perhaps, is what makes life in Mystic so exceptional. It has all the history and atmosphere of a classic New England village, with a picturesque coast to boot. It is this coast that chapter 6 illustrates, uncovering what makes a coastal life in Mystic so mystical.

The Asa Fish House, shown on the right in this early-1900s postcard, still stands at 21 East Main Street, housing the Lighthouse Bakery. Built in 1824 by Mystic entrepreneur, senator, and judge Asa Fish, the domicile remains in the same style and state as it did at its completion. The town's post office (still active today), was built in the house's garden (right foreground) in 1925. One unique quality of the Fish House is that it is one of the few structures in Mystic to never face the ravages of fire, and thus, has never been rebuilt.

HIGH STREET, MYSTIC, CONN.

This card displays High Street in Mystic in its dirt state back in 1908. While the street currently houses the Mystic River Historical Society (at 74 High Street), the history of High Street can be traced back much farther. At 76 High Street stands the Portersville Academy building, which was relocated to High Street from behind Union Baptist Church in 1887, and served as Mystic's first voting hall until 1958. Other historical sites on the street include the John Heath House (c. 1862), the Milton H. Ricker House (c. 1869), and the Thomas Ryley House (c. 1859).

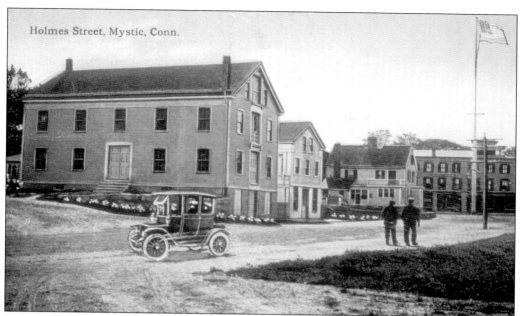

Holmes Street, Mystic, Conn.

Once the site of several shipbuilding and repair facilities, most of Holmes Street has evolved into upscale restaurants, such as the Engine Room and Anthony J's. Famous for its namesake family, that of the ship captain Jeremiah Holmes, hero of Battle of Stonington in the War of 1812, Holmes Street intersects East Main Street at the Liberty Pole and terminates at the S&P Oyster Company, just before the drawbridge that spans the Mystic River. The front of this card reads, "Holmes Street, Mystic, Conn."

View at Burnet's Corners, near Old Mystic, Conn.

Pub. by F.E. Williams

This pre-1915 postcard shows what appears to be the millpond that lies within a short distance of the intersection of Packer and Cow Mill Road, now a part of the Burnett's Corner Historic District. Although all that remains at this site are the ruins of the mill that used to run on Haley's Brook, the historic district is still of educational value in the Old Mystic area. The dam, which was used to channel the water that drove the mill works, predates the American Revolution. This card was published by F.E. Williams.

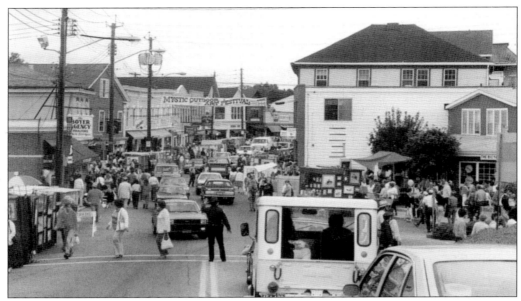

As the oldest annual festival of its kind in the Northeast, the Mystic Outdoor Arts Festival allows local writers, painters, and artists of all kinds to display their craft to the citizens of Mystic. This 1975 postcard shows the street scene from the ever-popular festival, held in August every year (and counting) for the last six decades. It draws over 85,000 in attendance.

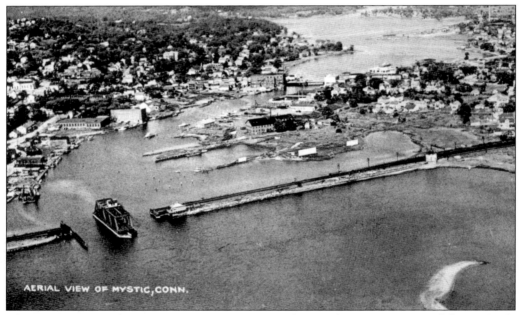

AERIAL VIEW OF MYSTIC, CONN.

Almost every iconic location in Mystic is present in this aerial overview postcard shot in 1952. In the foreground is the railroad bridge opening for a boat. Above that, on the right, is Pistol Point, and beyond that, the Mystic River Bascule Bridge, connecting West Main Street with East Main Street, and the majestic river itself. Visible farther north, upriver on the right, is the Mystic Seaport Museum, home to several museum ships.

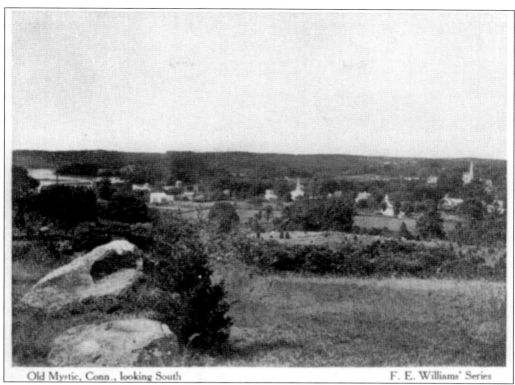

Old Mystic, Conn., looking South F. E. Williams' Series

This 1905 postcard shows a hilltop view looking south from Old Mystic on the east side of the river. The steeples of the Congregational church (center) and the Union Baptist Church (upper right) stand as if sentries to the river. The front of the card, which is only partially taken up by the picture so that there is more writing space, reads, "Old Mystic, Conn., looking South. F. E. Williams' Series."

Olde Mistick Village is one of the premier shopping areas in Mystic, with several boutique businesses set up with classic New England charm. The village is also home to several festivals, concerts, and events. In this undated postcard, a reenactor plays his role as a Revolutionary War–era town crier to perfection, even as he seems content to enjoy the duck pond on a balmy New England day.

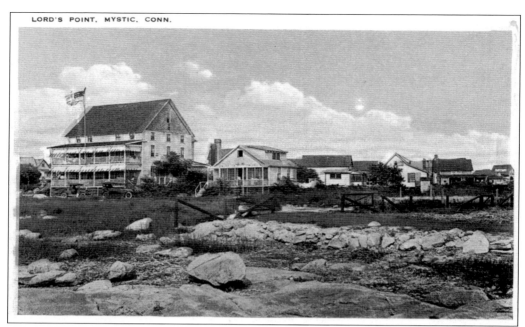

This 1920s Lord's Point view epitomizes a timeless Connecticut coastal lifestyle. Labeled here as Mystic (it is only minutes away), it is actually part of Stonington and was developed in the early 1900s when James E. Lord, a resident farmer, sold plots as summer home locations for Massachusetts residents. The building with the flag is the Stanton Inn, where community meetings were held. A fire (common in those days) destroyed it in 1928. The club space was replaced in 1931 by the resident-built Community House, still in use on the corner of James and Ashworth Streets.

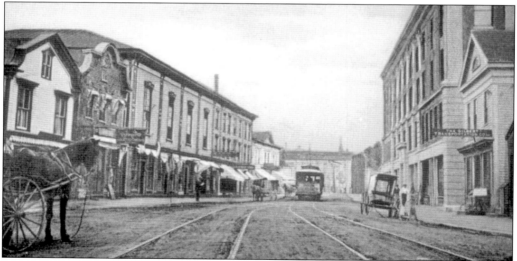

This card, published after 1904, shows West Main Street in the heart of Mystic. Visible are the tracks of the trolley that connected the towns of Mystic, Stonington, and Groton in 1904. A trolley prepares to cross the bridge, and on the right is the Gilbert Transportation company in the four-story brick Gilbert Block. Several horse-drawn carriages are also visible, meaning the automobile was not yet popular in Mystic. The card reads "West Main Street, Mystic, Conn."

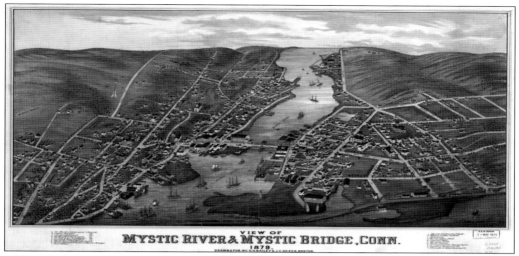

VIEW OF
MYSTIC RIVER & MYSTIC BRIDGE, CONN.
1879.
DRAWN & PUB. BY O.H. BAILEY & J.C. HAZEN, BOSTON.

Although this map is dated 1879, its appearance on a postcard may date to after 1898, when the Post Office Department implemented a lower postage for postcards. Notable in this 138-year-old map are the absences of the Gilbert Block on West Main Street, the Rossie Velvet Mill on what would be known as Greenmanville Avenue (at the top center in Mystic Bridge), and several other developments, like the powerhouse and the Mystic Museum of Art.

Although not as stunning as one of the aerial views, this 1890s map of Mystic (printed by the Book and Tackle Store much later) gives a more precise layout of the village in days gone by. Visible are the Hartford Railroad, Murphy's Point, and several churches. This card only shows the Stonington side of the divide, shortly after postal services for Mystic River (west side) and Mystic Bridge (east side) were merged.

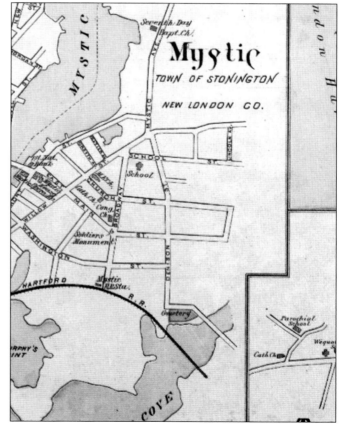

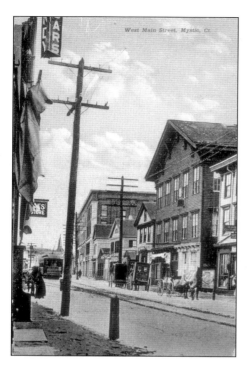

West Main Street has always been a center of commerce in Mystic, and this card shows the street in its pre-automotive glory, dated in 1909, as evidenced by the Groton Public Utility poles with multiple tiered crossbeams supporting the lines, and the trolley tracks in the middle of Main Street. Women do their shopping in clothing reminiscent of the ebbing Victorian era. The trolley proudly services the area, and horse-drawn carriages carry commuters to and fro.

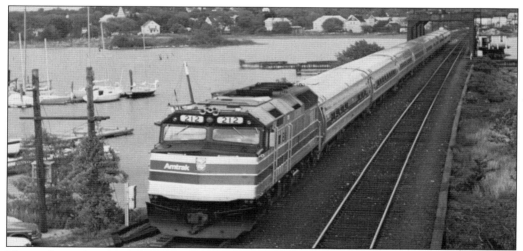

If one choo-choo-chooses the Senator, one will train him- or herself to have a comfortable ride! This General Motors F40PH, powered by a 3,200-horsepower diesel-electric engine, is shown pulling an Amtrak passenger train up the tracks near Mystic. The back of the card reads, "The Senator, powered by Locomotive Number 212, a F40PH, is viewed at Mystic, Connecticut. The Amtrak Train is equipped with the new Amfleet Equipment assuring the ultimate in passenger comfort." The F40PH was retired by Amtrak in the 1990s, to be replaced by the GE Genesis.

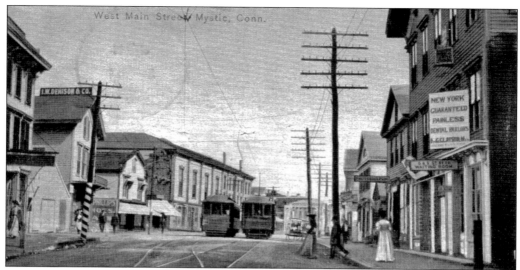

This 1909 view looking east along West Main Street features two trolleys. The utility pole on the left is painted in black–and–white stripes, likely warning the driver of merging tracks. Fares to New London at the time were around 20¢, and some trolleys were designated to transport schoolchildren only (departing from the local car barn at 7:00 a.m.. The trolley tracks were built in the early 1900s by over 100 Italian laborers who lived in tents on-site and worked feverishly until the grand opening on April 9, 1905. (Courtesy of Groton Public Library.)

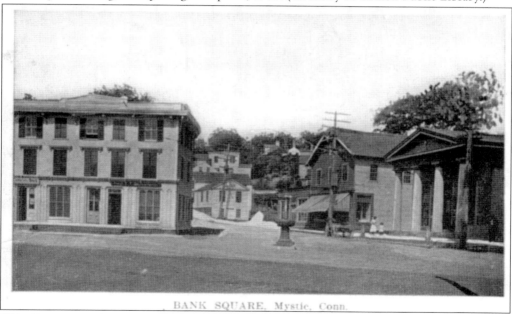

This 1915 postcard displays Bank Square, at the intersection of West Main and Water Streets. Built in 1851 in Greek Revival style, the iconic four pillars of the Mystic River National Bank can be seen to the right of this photograph. An iron horse trough, equipped with a light for evening visits, sits in the center of the intersection, and has since been moved to the sidewalk in front of what is now Bank Square Books. Local children were rumored to occasionally share a drink of water from it with the horses.

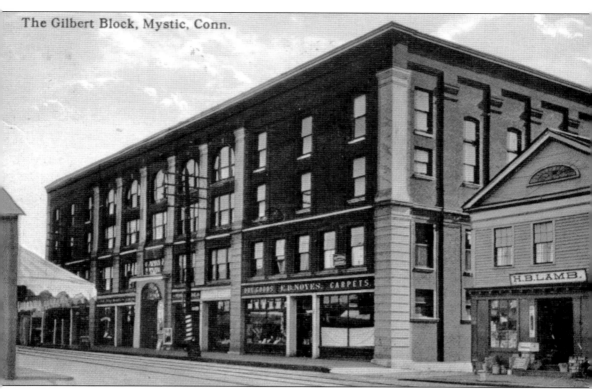

This 1921 card shows the Gilbert Block, built by brothers Mark and Osgood Gilbert in the early 1900s on West Main Street. It housed an office for their adjacent shipyard, as well as homes, other storefronts, and Mystic's first silent movie theater. By 1909, the Gilberts were rumored to have built everything as a scheme to profit from insurance money for faulty ships. It suspiciously burned to a shell in 1915 and was not rebuilt until 1924. Today, it is owned by the Steamboat Wharf Company and houses the delicious Mystic Sweets & Ice Cream Shoppe.

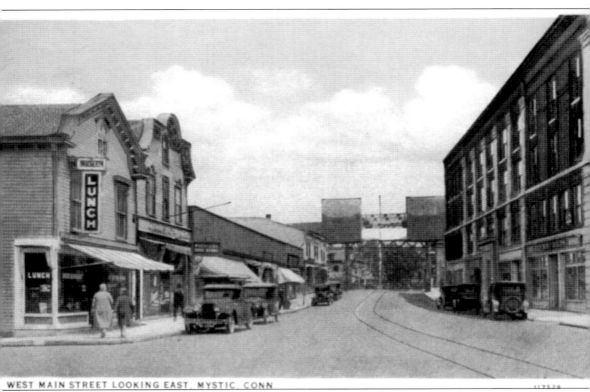

WEST MAIN STREET LOOKING EAST, MYSTIC, CONN.

This post-1921 postcard shows a view looking back along West Main Street towards the bridge. Several early automobiles are visible, as are the by then defunct trolley tracks. A diner sits on the left corner, and several shoppers are seen going about their business on the main drag. In the distance, one can see the Mystic Liberty Pole, a replacement for the original that was lost in a fire in 1885. To this day, the Mystic Liberty Pole occupies the corner of Main and Holmes in front of S&P Oyster Company. (Courtesy of Groton Public Library.)

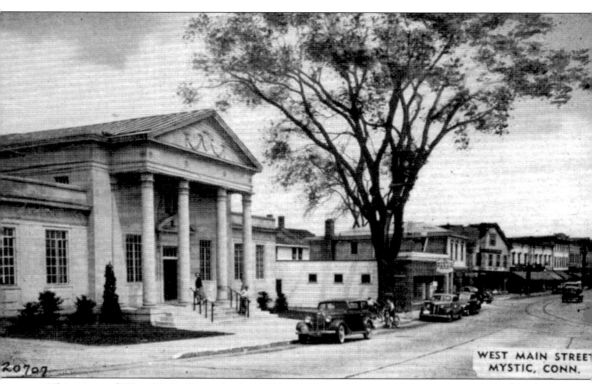

WEST MAIN STREET
MYSTIC, CONN.

This view of West Main Street in the 1930s displays the Mystic River National Bank, which was newly constructed with granite in 1931 in a Greek Revival style (the original building was established in 1851 and lacked the two side wings). Today, the building houses a Bank of America branch. A stage in the early evolution of the automobile is clearly seen here, as well: gone are the Model T–style cars, replaced by coupes with radial tires and flared fenders.

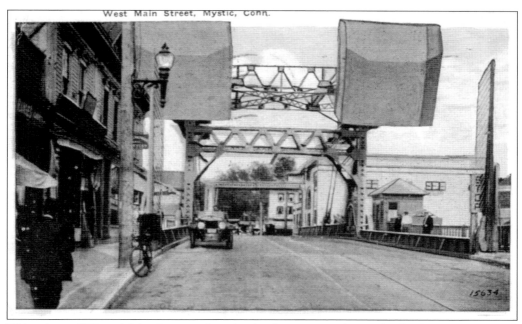

This view of West Main Street, taken in the late 1920s, shows the bridge in its current construction. Cars travel to and fro, in and out of Mystic proper, as commerce spreads throughout New England. Of note is the lowering "stop" boom, which has been replaced with modern railroad crossing blocks. Visible are the building that now houses Drawbridge Ice Cream and the location of what is now Mystical Toys, on the right side of the road just beyond the bridge.

This modern map is a postcard that shows the entirety of the state of Connecticut, with cities such as Hartford, New Haven, and Stamford visible, as well as tourist attractions such as Yale University, Powder Ridge, and the Stonington Lighthouse. Mystic, despite its status as an unincorporated village, is recognized not only for its locale but also for containing the ever-famous Mystic Aquarium and Mystic Seaport. This is a testament to the importance of Mystic to the state.

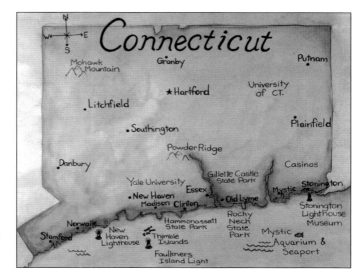

Mystic's location on the water allows some of the dining locales to have their own special charm. Red 36 is one of these locales. Pictured on this Ellery Twining postcard, Red 36 is a staple for both Mystic locals and sailors on the river who wish to grab either a bite of food or a cold beer to knock the edge off on a humid Mystic summer day. The establishment serves primarily American fare and is rated highly in *Connecticut Magazine*'s "Best Connecticut Restaurants of 2016." (Courtesy of Ellery Twining.)

This image of Twisters Ice Cream, on Greenmanville Avenue as one drives down Route 27 into Mystic, is one of several modern scenes of local life captured by local postcard artist Ellery Twining. This roadside ice-cream stand is perfect for grabbing a cone to cool off in the dog days of summer. The card is captioned "Ice Cream Social at Mystic, CT." (Courtesy of Ellery Twining.)

Ellery Twining has an eye for the romantic, as evidenced in his stunning image of the benches at Mystic River Park. The benches are a popular hangout spot for young lovers and old romantics alike, as people can lazily watch the ships and schooners coast into harbor while sitting next to the one they love. (Courtesy of Ellery Twining.)

Although the Plymouth Cordage Company was a mainstay of Plymouth, Massachusetts, part of its heritage has found its way to the Mystic Seaport Museum. This card shows a 250-foot segment of the original 1,150-foot walk built in 1824 in Plymouth, Massachusetts. This rope and several parts of the original machinery are on display in the Mystic Seaport, which is open for varied hours throughout the year.

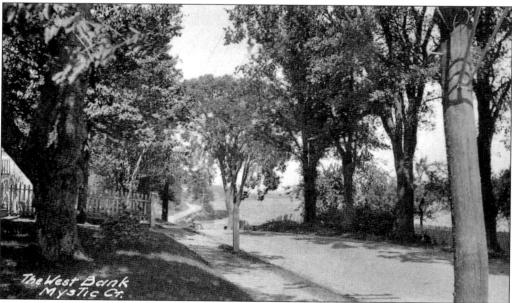

This undated postcard greets viewers with an artist's rendition of the west bank of the Mystic River. Several historic homes are listed on this road with spectacular river views, including 99 River Road, built in 1853 by Eleanor Lawson and later occupied by Capt. William Yates; the almost identical 105 River Road, built in 1853 by Huldah Norris; and 119 River Road, a two-and-a-half story, gable-roofed, clapboard house built in 1864.

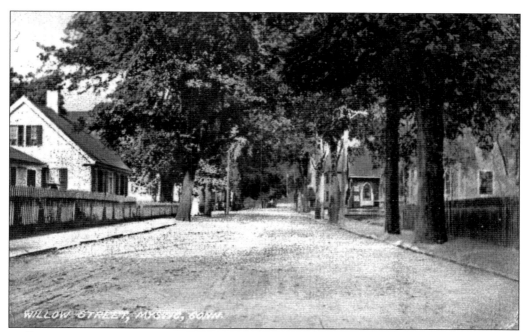

Willow Street (on the east side of the bridge) plays a grand history as one of the first residential streets in Mystic. By the early 1800s, twelve homes existed on the street, which extended down to what was then the ferry landing, later known as Pistol Point and today the home of the upscale award–winning dining establishment Red 36. The front of this 1908 card reads, "Willow Street, Mystic, Conn."

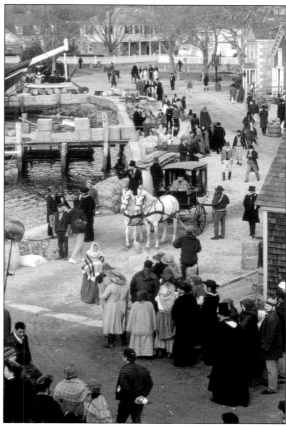

Although lacking in historical accuracy, Steven Spielberg's film *Amistad* is nonetheless a historical testament to the events surrounding this sordid affair. Movies such as *Amistad* are a boon to the local economy and are thus welcomed as often as filmmakers can find reason to shoot in Mystic. This card was of a limited edition, handed out to both the people of Mystic and to those who worked on the blockbuster film. Taken at the Mystic Seaport, this view depicts one of the pivotal scenes in the film.

109

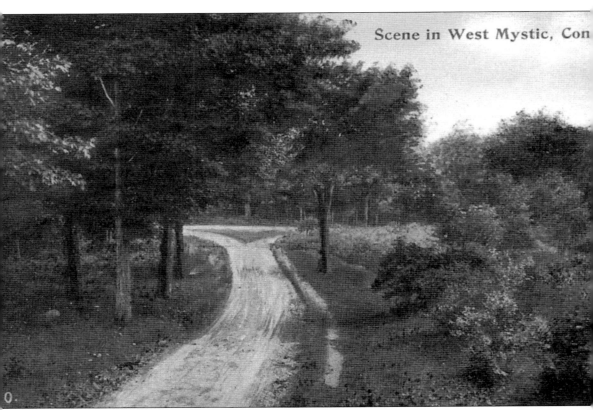

Sometimes, Mystic is the type of place where one takes the time to visit the streets that have no name. This watercolor shows a wooded scene in an unidentified locale in Mystic. Connecticut is a state of forests, so it should come as little surprise that a quaint woodland retreat existed like this at one time in Mystic. The front of the card reads, "Scene in West Mystic, Conn."

Seven

A Seasoned Yankee
Mystic through the Seasons

Mystic's summers are generally shorter and the winters longer than in much of the country, but the region of southeastern Connecticut where Mystic dwells still famously holds the distinction of being generously graced with all four seasons. The temperate New England weather is influenced heavily by the mighty Atlantic; however, not even a frigid nor'easter or fierce hurricane can convince the Mystic faithful that their village is anything less than perfect.

That is not to say that the locals are unable to enjoy their home. Rather, the ebbs and flows of the lives of the villagers effortlessly transition to celebrate the cyclic seasons of the year. Spring brings the drawbridge back to life, fulfilling its regular schedule as the ships and schooners sail through. Spring also brings the trees and flowers to life, allowing young lovers a dalliance in the Mystic River Park as the blooms and petals flourish. Spring gives way to summer, with dining outdoors, sunset sails, and all the fairs and celebrations one could desire. Fall gives way to shorter days and crisp air, with riverside strolls accented by vibrant, colorful leaves and chilly morning mists. Winter blankets the coastline in snow, but spurs the town into festive celebrations as the denizens cheerfully gather for shopping, the annual Community Carol Sing, or a joyous New Year's Eve party with the beluga whales at the Mystic Aquarium.

These postcards share the best that every season has to offer Mystic and those who visit, proving that, year-round, Mystic is both a grand place to head for vacation and an even better place to live.

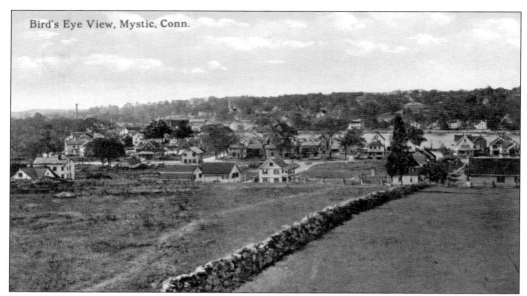

Bird's Eye View, Mystic, Conn.

This bird's-eye view shows West Mystic in the late spring sometime during the 1910s. This scene would most likely be spied either sometime in late May or early June, as spring in this region tends to begin later than in many parts of the country. The new, large brick Mystic Academy building with smoke rising from the chimney can be seen across the river at right, and the white steeple of the Union Baptist Church can be seen not far from it to the left.

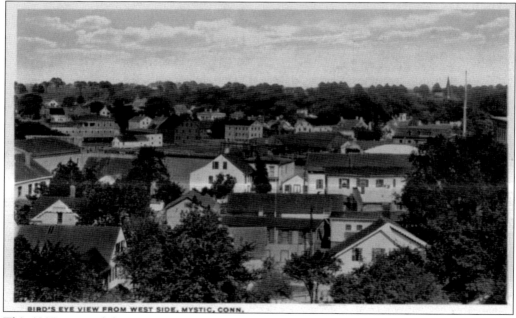

BIRD'S EYE VIEW FROM WEST SIDE, MYSTIC, CONN.

This 1915 postcard depicts an early autumn view of the east side of Mystic River, not far from the bridge. The brick building at far right is the Gilbert Block, and a little to the left of that is the iconic Mystic Liberty Pole, erected in 1862. It now stands in front of S&P Oyster Company on East Main Street. Beyond that are the two steeples of St. Patrick Roman Catholic Church and the Congregational church.

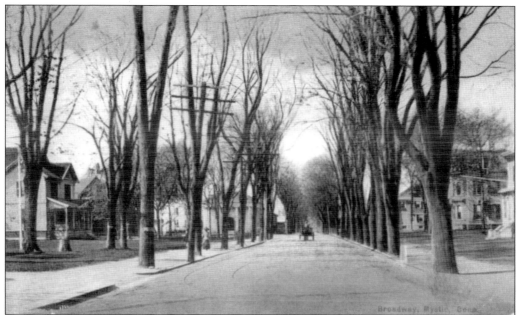

A carriage reaches the intersection of Broadway and East Main Streets in late April around 1880. Public utilities arrived in 1879, and the Soldiers' Monument (not pictured here) was erected at this intersection in 1883. This postcard was printed sometime around 1907 and was actually sent twice—to Massachusetts and to Rhode Island (postmarked on December 25 at 9:00 a.m. from Mystic), with the message, "Hello Frank—Merry Xmas. Having a good time and a square meal. More in a while."

This 1980s postcard features local artist Lynn Anderson's handiwork, along with a tasty New England recipe for classic Victorian Christmas sugar cookies. The card originally came from a series of books first printed in the 1980s that compiled traditional New England holiday recipes that Mystic Seaport member families have enjoyed for generations and generously contributed for publication.

Christmas Memories
Cookie-Cutter Cookies

1 cup butter
½ cup sugar
2 ½ cups flour
1 tsp extract of choice
 confectioner's sugar glaze

Cream butter and sugar. Add flour and extract. Form into ball and chill. Roll dough on floured surface, cut into shapes and bake at 300° until edges brown. Cool, glaze and decorate.

Christmas Memories
Wassail

1 gal. apple cider • ¼ tsp powdered mace
1¾ c. packed light brown sugar
6 2" cinnamon sticks
1 Tbs whole cloves • ½ tsp. salt
1 Tbs powdered allspice
pinch crushed red pepper
¼ c. lemon juice • 2 c. brandy

Bring all ingredients except lemon
juice and brandy to a boil. Reduce
heat to low, cover, steep 30 mins.
Cool & strain twice through cheesecloth.
Refrigerate. At serving, reheat gently,
adding lemon and brandy.

This 1988 wassail recipe postcard comes from the vintage *Christmas Memories* book, a collection of traditional New England recipes contributed by local Mystic Seaport member families. Wassailing is a customary part of Mystic Christmas festivities, when carolers from places like Ledyard High School, Mystic River Chorale, Mystic Noank Community Brass Choir, Union Baptist Bell Choir, and Pine Point Chamber Choir go "a-wassailing" through downtown Mystic. Wassailing is a Victorian tradition in which the poor would carol for the rich to earn warm food or drink.

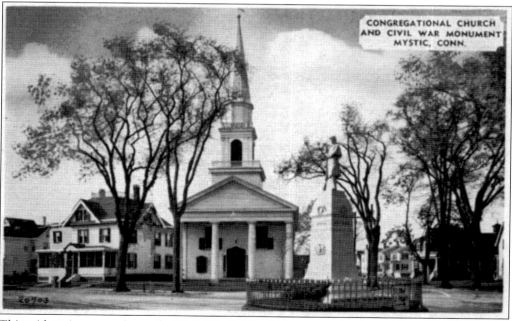

CONGREGATIONAL CHURCH
AND CIVIL WAR MONUMENT
MYSTIC, CONN.

This mid-spring scene shows the Civil War Soldiers' Monument in the middle of the roundabout in front of the United Congregational Church at the intersection of Broadway and East Main Streets. A sign on the fence of the monument reads, "Slow," an indicator that Connecticut drivers have pretty much always liked to speed.

Deans Mills. Mystic, Conn.

In this late-1800s postcard, a young couple takes a spring stroll along Lover's Lane, a beautiful trail that sliced through the Dean Mills property and skirted what was then called Dean's Pond, located northeast of Mystic. Dean's Pond was named for the local Dean family, blacksmiths who moved there from Massachusetts in the late 1600s and eventually built two fulling mills. The pond provided power for local gristmills and textile mills, and today, it is a protected reservoir.

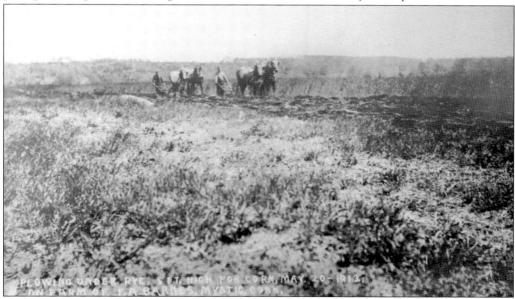

This 1912 postcard shows a horse-powered plow on the Mystic River farmland of Frederick Avery Barnes in May, plowing for corn. The following month, the farmworkers would be haying. Earlier that year in January, Frederick Barnes joined fellow Mystic local Charles Q. Eldredge in Puerto Rico, visiting Pomello's Fruit Co. Plantation. A Howard Johnson hotel is now located on the former farmland, and Mystic's Barnes Moving & Storage Company (still in operation) was run by the family until 1999.

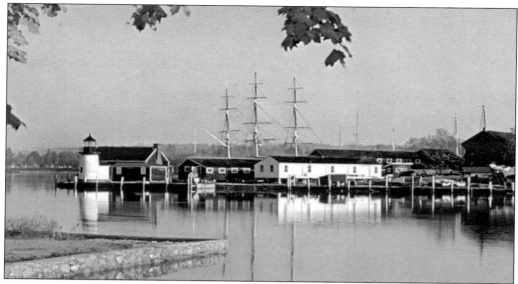

Autumn leaves frame this crisp fall view of the west tip of the Mystic Seaport, taken sometime in the 1980s or 1990s. The lighthouse pictured here was built in the 1960s and is actually a nonfunctioning replica of the Brant Point Lighthouse (built in 1901) in Nantucket, Massachusetts. The masts of the *Joseph Conrad* can be seen behind the buildings of the seaport's historic replica of the early Mystic maritime village, which thousands of tourists and locals alike visit each year.

A handwritten "Greetings from Mystic" postcard from 1910 features a now common fragrant flower known as a beach rose (*Rosa rugosa*). The bud depicted in the rear of the bouquet and the small flower beside the rose in the front are an invasive species brought from England and planted by locals to prevent beach erosion. It was just beginning to spread to beaches all over southeastern Connecticut in the early 1910s and now grows on nearly all of them.

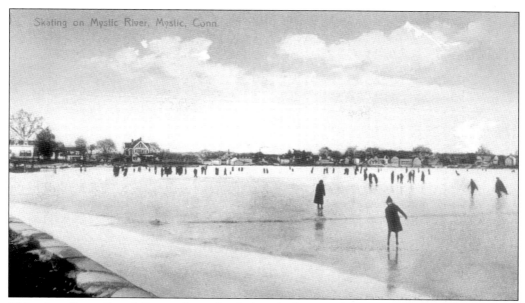

This view from Gravel Street shows locals ice-skating on the Mystic River in early spring sometime in the 1910s. It was not unheard of for rivers in New England to remain frozen well into the spring, especially if preceded by a harsh winter that could freeze the water for feet beneath the surface, which likely explains why some of the trees bordering the river in this picture have green leaves on them.

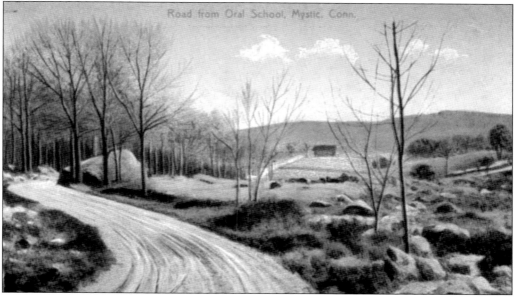

A picturesque spring road from the Mystic Oral School for the Deaf is seen here in the 1910s. The school was founded as the Whipple Home School for Deaf-Mutes in 1869 in Ledyard (Quakertown) by Zerah Whipple, whose grandfather successfully taught her deaf uncle to lip-read and communicate using Whipple's Natural Alphabet. In the 1870s, the school was relocated to the Silas Burrows House, seen in the distance here, and was renamed the Mystic Oral School. The family operated it until 1921, and in 1980, it was closed by the state.

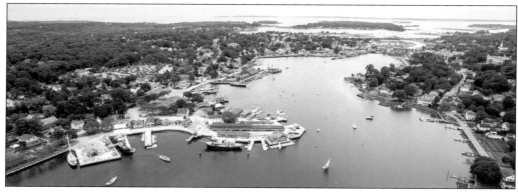

This modern aerial view of Mystic taken in the 1970s shows a fairly familiar picture of the town, though at this point, some of Mystic's most famous businesses were not yet there, like the S&P Oyster Company (built right beside the bridge in the 1990s on the east [right] side, behind the Mystic Liberty Pole) or the Steamboat Inn on the west (left) side of the bridge behind the large, brick Gilbert Block building.

EAST MAIN STREET, MYSTIC, CONN.

PUBLISHED BY H. D. UTLEY, NEW LONDON, CONN.

A turn-of-the-century horse and carriage travel past shipping magnate and local entrepreneur Charles Henry Mallory's snow-blanketed home on East Main Street. At this point in time, the eastern town was called Mystic Bridge, and the west side of the river called Mystic River until 1890. An advertisement seen to the right of the street peddles "Best Cough Syrup," which, in those days usually included heroin—even for kids. This card was published by H.D. Utley, whose business was located on State Street in New London.

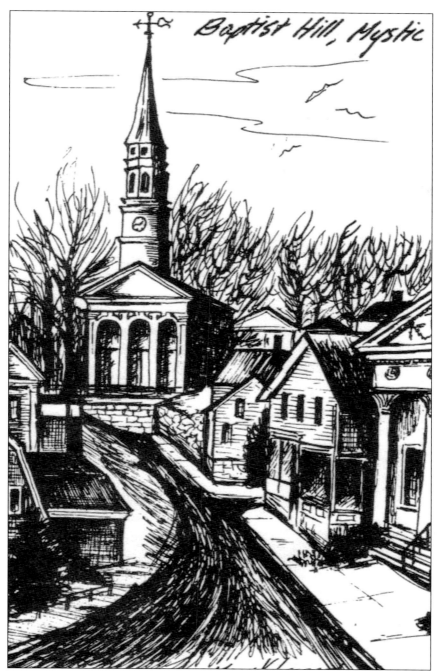

Local artist and Connecticut College alumna Mary V. Leonard's modern winter rendition of Baptist Hill in Mystic, Connecticut, was probably drawn sometime in the mid-20th century. Postcards like this one are sold by local artists like Mary Leonard at the Mystic Outdoor Arts Festival, which was started in 1956 and is now the longest-running of its kind in the Northeast. The festival, which celebrated its 60th anniversary in 2016, still happens every year in August, showcasing 250 local artists and drawing over 85,000 visitors.

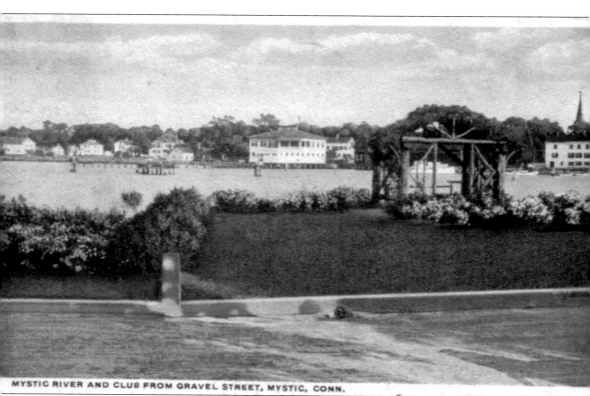

MYSTIC RIVER AND CLUB FROM GRAVEL STREET, MYSTIC, CONN.

Shards of summer sunlight slice through the trees, spilling onto Gravel Street in this late–1910s view of the Mystic River and the Mystic Club, situated on the parallel Holmes Street. The Mystic Club was originally founded as the Mystic Cosmopolitan Club in 1911. The organization and building were founded and constructed as a central gathering location for players of popular sports like boating, dancing, swimming, bowling, billiards, or card games. It also housed a library. (Courtesy of Groton Public Library.)

Olde Mistick Village, Conn.

This modern photograph of Olde Mistick Village, a replica of the 1720s seaport village (across the street from the Mystic Aquarium). The area features some of the best restaurants in Mystic alongside famous shops like the Boardwalk gift shop and Franklin's General Store, as well as jewelers, chocolatiers, and the Mystic Luxury Cinemas. Christmastime is the perfect season to visit; annual Christmas caroling events, the Festival of Lights, and the Holiday Carnival bring thousands of locals and tourists together for scenic holiday cheer.

CONNECTICUT

This summer snapshot from the Olde Mistick Village features a replica mill over what locals refer to as the beloved "duck pond," laced with benches shrouded comfortably in the shade of leafy trees. Village goers (especially children and dogs, both of whom are allowed there for walks) love to gather to watch the colorful ducks, who raise several ducklings here each year, but please do not feed them (the ducks).

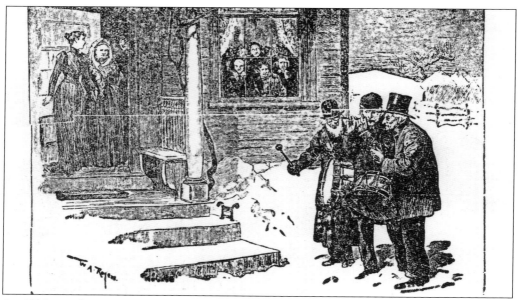

An 1888 woodcut print postcard, courtesy of Ellery Twining, shows a trio of musicians playing Christmas carols in the snow outside a home while the family gathers in the window and on the porch to listen. Today, the Mystic Seaport hosts a massively attended annual Community Carol Sing, which celebrated its 70th anniversary in 2016 and is led by University of Connecticut director of choral studies and beloved former Ledyard High School music teacher Jamie Spillane. Carolers come from all over the country to donate a canned food item in exchange for participation. (Courtesy of Ellery Twining.)

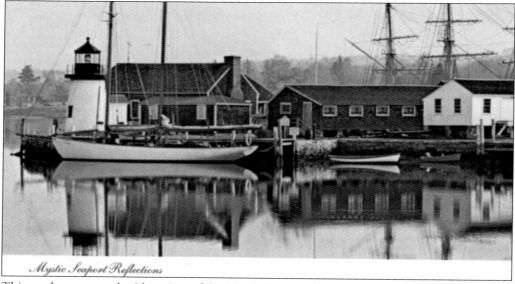

This modern postcard with a view of the Mystic Seaport, located on the east side of the Mystic River, is captioned on the back: "Mystic Connecticut is reflected in the tranquil Mystic River. The Schooner Brilliant is docked at left and the three-masted training ship *Joseph Conrad*, built in 1882, is at right. The Seaport is an outdoor-indoor maritime museum depicting life in the nineteenth century."

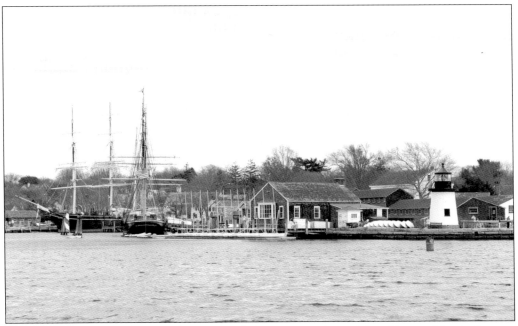

This 2000s wintery photographic postcard shows a portion of the 19-acre Mystic Seaport Harbor, with the moored whaler *Charles Morgan* (pointing to the left) and the ship *Joseph Conrad* (facing the *Charles Morgan*). Mystic Seaport opened in 1929 to preserve Mystic's seafaring history and is the nation's leading maritime museum. (Courtesy of Ellery Twining.)

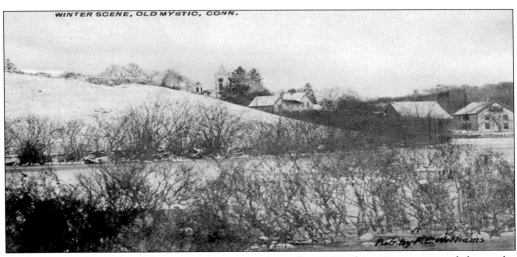

With a view of a cold and frosty morning sometime after 1907, this wintry postcard shows the ice-and-snow-covered terrain of Old Mystic. In 1890, due to the installation of a new post office in Mystic, the area of Mystic north of what is now I-95, above the head of the Mystic River, became known as Old Mystic. In 1963, the town was given its own zip code (06372) as it developed a separate identity from the area around the bridge. Today, the area is home to the Indian and Colonial Research Center, which is housed in the old Mystic Bank Building at 39 Main Street, on Route 27. This card was published by F.E. Williams.

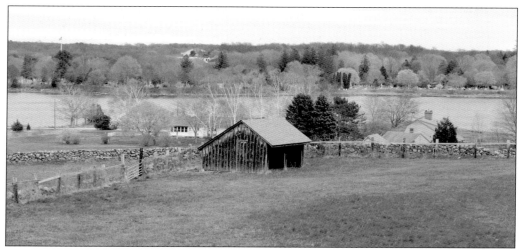

Trees flower and bud in this springtime view of the Elm Grove Cemetery, situated on the east side of the Mystic River. This view was taken by Ellery Twining on River Road (west side of the river). To the left, not pictured, is the Interstate 95 bridge, flanked on its south side by the Jerome Hoxie Scenic Overlook, which was dedicated in memory of local artist Jerome Hoxie in 1966. It features a plaque with a brief local history and a map and is a perfect place to take pictures.

Spring breathes life anew with firm yellow daffodils reaching through iron fencing at this local Mystic home after the chill of winter breaks. This is another modern photographic postcard from Ellery Twining. Iron fences like this one are not an uncommon sight in Mystic and were all the rage between 1860 and 1880, when plenty of them were being installed. The fences are now either preserved, restored, or replicated.

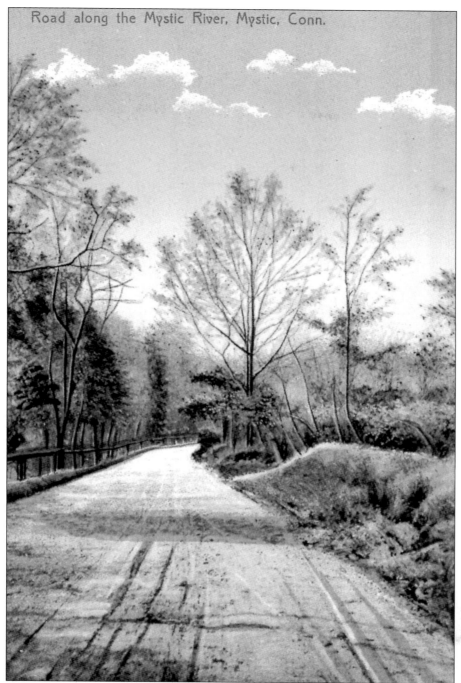

Road along the Mystic River, Mystic, Conn.

An 1890s or early-1900s springtime view of a dirt road (possibly Holmes Street) along the east side of the Mystic River, guarded by a wooden fence, is seen here. The postcard, never sent, was published by the E.P. Judd Company in New Haven, Connecticut, but made in Germany sometime after 1907, as German companies were considered to be the highest-quality postcard printers at the time.

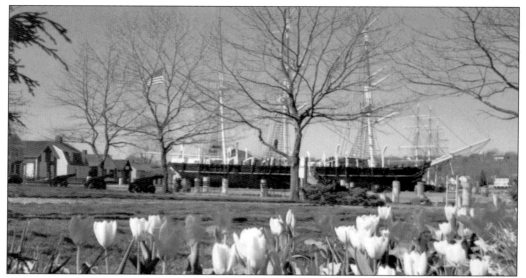

Colorful tulips spring from the ground in this 1989 postcard snapshot of the Mystic Seaport, likely undergoing preparations for the annual summer field trips to begin in the following months from organizations far and near, like Ledyard Parks & Recreation's Summer Playgrounds (which bills it as a favorite). The three-masted whaleship the *Charles W. Morgan* looms large while moored in the background. Three 19th-century replica cannons placed on the edge of the Seaport's town green face the ship as a man climbs on its rigging.

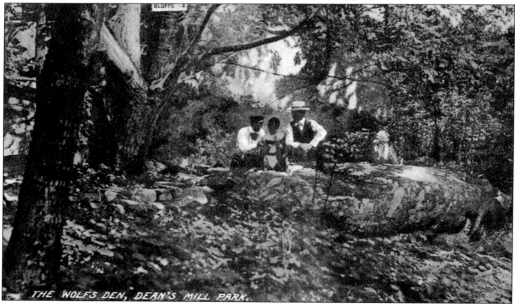

THE WOLFS DEN, DEAN'S MILL PARK.

This 1908 postcard depicts African Americans gathered together with their dog at the Wolf's Den in Deans Mill Park. By 1910, there would be 216 African Americans in Stonington and Groton combined, many of whom were direct descendants of slaves, if not freed slaves themselves. The water company closed the park in 1922 to prevent pollution to the reservoir. The Wolf's Den is just a few steps into the woods on the east side of Deans Mill Reservoir Dam. (Courtesy of Cody L. Ray.)

A Camp Mystic camper swings a tennis racket in this summer shot from the early 1920s. Camp Mystic was a 45-acre girls' summer camp opened in 1916 by philanthropist Mary Jobe Akeley, one of the first women to explore Africa. It served locally sourced food, and several prominent explorers of the day spent time with the girls there. Sadly, the camp closed during the Great Depression, and its trustees transformed it into a public peace sanctuary in the 1980s. Today, it is a wildlife retreat open to the public.

Mystic Valley, an oil painting on canvas published on a postcard by the Florence Griswold Museum of Old Lyme, was painted by Edward H. Barnard (1855–1909), a landscape painter who studied at MIT, the School of Drawing and Painting in Boston, and Académie Julian in Paris. He spent summers in Mystic from 1890 to 1900 while teaching at Bradford College, during which time he painted this tranquil, historic river scene.

Discover Thousands of Local History Books Featuring Millions of Vintage Images

Arcadia Publishing, the leading local history publisher in the United States, is committed to making history accessible and meaningful through publishing books that celebrate and preserve the heritage of America's people and places.

Find more books like this at
www.arcadiapublishing.com

Search for your hometown history, your old stomping grounds, and even your favorite sports team.

Consistent with our mission to preserve history on a local level, this book was printed in South Carolina on American-made paper and manufactured entirely in the United States. Products carrying the accredited Forest Stewardship Council (FSC) label are printed on 100 percent FSC-certified paper.

MADE IN THE
USA